# The Accademia Galleries in Venice
## guide

*Translation*
Ivor Neil Coward

*Edited by*
Giovanna Nepi Scirè

*Scientific Coordination*
Sandra Rossi

Reprint 2013
First Edition 2008

© Ministero per i Beni
e le Attività Culturali
Soprintendenza speciale per il patrimonio
storico, artistico ed etnoantropologico
e per il polo museale della città di Venezia
e dei comuni della Gronda lagunare

An editorial production by
Mondadori Electa S.p.A., Milan

www.electaweb.com

Ministero per i Beni e le Attività Culturali
Soprintendenza speciale per il patrimonio storico, artistico ed etnoantropologico
e per il polo museale della città di Venezia e dei comuni della Gronda lagunare

# The Accademia Galleries in Venice

## guide

**Electa**

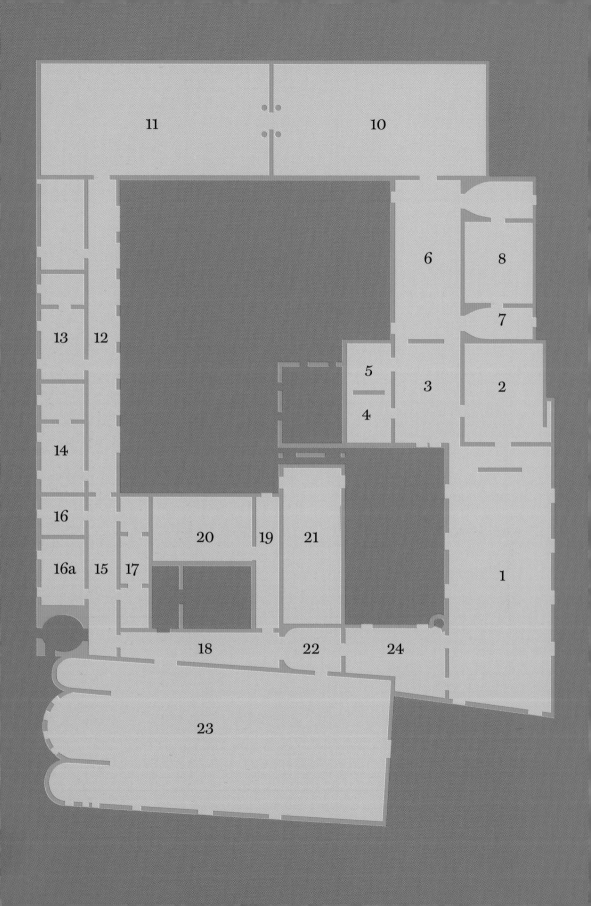

| Room | | Page |
|---|---|---|
| 1 | The Primitives | 18 |
| 2/3 | The Great Fifteenth-Century Altarpieces and Giovanni Bellini | 24 |
| 6 | Titian, Jacopo Tintoretto and Paolo Veronese | 28 |
| 7/8 | Lorenzo Lotto, Romanino and Jacopo Palma il Vecchio | 32 |
| 10 | Titian, Jacopo Tintoretto and Paolo Veronese | 34 |
| 11 | Bonifacio Veronese, Jacopo Tintoretto, Bernardo Strozzi and Giambattista Tiepolo | 40 |
| 12/13 | Andrea Mantegna, Piero della Francesca, Cosmè Tura, Giovanni Bellini, Giorgione, Jacopo Bassano and Jacopo Tintoretto | 46 |
| 14 | Seventeenth-Century Paintings | 56 |
| 15 | Giovanni Antonio Pellegrini, Giambattista Tiepolo and Giannantonio Guardi | 58 |
| 16/16a | Early works by Giambattista Tiepolo, Alessandro Longhi, Giambattista Piazzetta and Fra' Galgario | 62 |
| 19/20 | Bartolomeo Montagna, Giovanni Agostino da Lodi Boccaccio Boccaccino and "Stories of the Relic of the Cross" | 72 |
| 21/22 | Vittore Carpaccio's "Saint Ursula" Cycle and Neoclassical Hallway | 76 |
| 23 | Former Church of Santa Maria della Carità. Works from the Veneto School of the Fifteenth Century and Canvases from the Scuola di San Marco | 80 |
| 24 | Former Albergo Room of the Scuola di Santa Maria della Carità. Antonio Vivarini and Giovanni d'Alemagna, Titian | 90 |

# The Accademia Galleries
Giovanna Nepi Scirè

In the early 1800s, the Galleries of the Accademia—containing the most important collection of fourteenth to eighteenth-century Venetian painting—along with the Brera Picture Gallery and Bologna Accademia, became a museum with very political origins, closely connected to the local events that, in those years, had reduced Venice to little more than a prize passed around among the great European powers.

With the annexation under the Napoleonic Kingdom of Italy after the treaty of Presburg on December 26, 1805, and through various decrees (1805, 1808 and 1810), all the public palazzi and religious buildings were closed, and others were even destroyed. The artwork that surfaced from these events and which was somehow not sold or lost, found protection in the new Galleries. Originally, however, the Galleries' purpose was largely as an instructional tool, as is shown in the decree of September 1, 1803, extended on February 12, 1807 also to Venice, which established that—alongside an academy of fine arts divided into various faculties—there would be a gallery for the "benefit of those who practice painting."

The Venetian Academy of Fine Arts was also forced to relocate from the Fonteghetto della Farina (small wheat warehouse) to a group of buildings which included the convent of the Lateran Canons, designed by Andrea

Giorgione.
*The Tempest*, detail

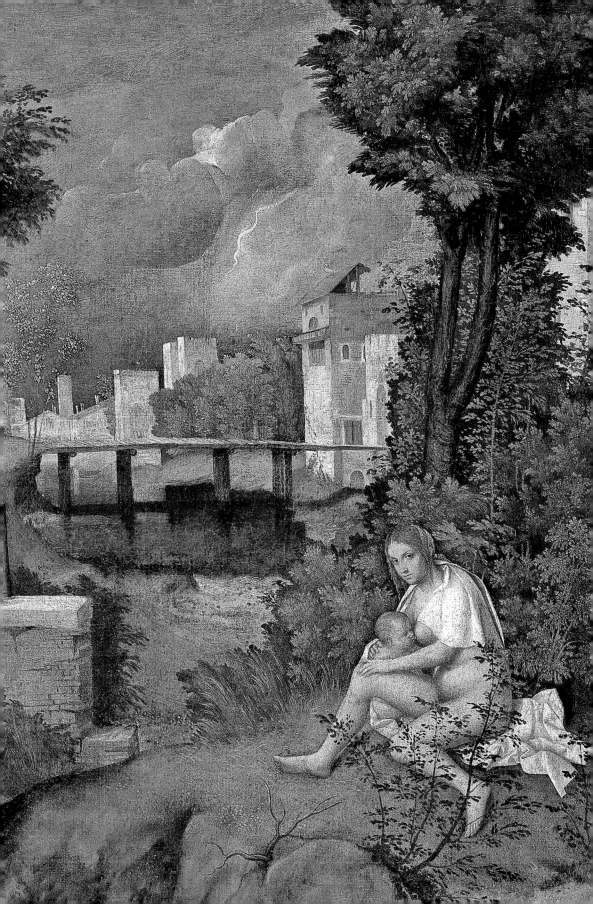

Palladio in 1561, the Church of La Carità, reconstructed by Bartolomeo Bon between 1441 and 1452, and the Scuola della Carità, the first of the great Venetian schools, founded in 1260. Thus there was also the problem of how to incorporate the works of art into structures whose original purpose was entirely different, and which were not connected to one another in any way.

The restructuring project was led by Giannantonio Selva and lasted until 1811. It was necessary to completely gut the church which, once the furnishings and altars were removed, was then divided horizontally and vertically to create five large rooms on the lower floor for the school and two on the upper floor to serve as exhibition rooms. These spaces were created after walling over the Gothic windows, with illumination coming from above. The buildings were connected by opening a passageway on the first floor at the back wall of the Albergo Room, and constructing a short stairway which led through a foyer to the other rooms.

The rooms of the Scuola della Carità were largely left the same: the wooden ceiling from the late fifteenth century is still in the Albergo Room (Room 24), as are the triptych by Antonio Vivarini and Giovanni d'Alemagna dated at 1446, and Titian's *Presentation* which dates from August 31, 1534 to March 6, 1539. Also intact—aside from the fact that the altar was removed—is the great old Assembly Hall with the Primitives (Room 1), where the sumptuous ceiling remains on display with its deep blue and gold lacunars, carved by Marco Cozzi from 1461 to 1484. The five central high-reliefs were removed around 1814, and were replaced with four *Prophets* by

**Room 21**
(Vittore Carpaccio's
"Saint Ursula" Cycle)

**Rooms 4 and 5**
Before dismantling in 2006, when work commenced
to reinforce the foundation of the buildings during
the expansion of the museum

Domenico Campagnola or Stefano dell'Arzere, from the Scuola della Madonna del Parto in Padua, and a *Holy Father* traditionally attributed to Alvise Vivarini, but more likely by Pier Maria Pennacchi, once in the Venetian chapel of San Girolamo. It was decidedly more difficult to reconfigure the Palladian convent, however, especially since its integrity had already been compromised by a fire in 1630. Selva approached it with caution: the arcades of the Ionic loggia were closed, leaving some half-moons for lighting and to provide greater exhibition surface; the windows on the Sant'Agnese canal were raised, and the cells on the last floor were modified to create the engraving school and housing for the professors. On August 10, 1817, the gallery was opened to the public for a short time, with a great number of visitors. The first items to be included in the collection were a small number of artists' works, donations and trial works by the members of the Academy which were brought over from the old Academy, some of the remaining paintings from the Scuola della Carità, and the collection of plasters of Abbot Farsetti acquired from the Austrian government in 1805. Other important works were sent to the Brera Gallery in Milan, but luckily some paintings were added that France had returned, among which Paolo Veronese's famous *Christ in the House of Levi*. Others were removed from Venetian churches, such as that of San Giobbe, and placed in the Accademia Galleries as a precautionary measure, and yet other paintings were added from the first private contributions to the gallery. Some acquisitions—which were significant although few when compared with the enormous availability on the market—

**Room 10**
Titian, Jacopo Tintoretto
and Paolo Veronese

further enriched the patrimony. This notwithstanding, the collection continued to favor and protect Venetian painting—as it does now—and so was not particularly suitable for a well-rounded artistic education. During the 1800s, much effort was made to balance out this situation until the end of the century, when interest in the didactic aspect had all but vanished and with it the desire to expand the breadth of the gallery's collection.

Nonetheless, the Accademia anticipated the intentions of the Brera Gallery and through Abbot Celotti acquired Giuseppe Bossi's prestigious drawing collection, which boasted more than three thousand pieces and included—in addition to folios by Leonardo da Vinci and the famous *Vitruvian Man*—drawings from the Bolognese, Roman, Tuscan, Ligurian and Lombard schools, not to mention the German, French and Flemish schools that provided a certain uniformity to the collection of paintings.

As the number of artworks increased, so too did the exhibition spaces become (and so will they always be) wholly insufficient and overcrowded. The expansion project designed by Selva, who died in 1819, was completed under the supervision of Francesco Lazzari, and provided for two large halls to the left of the Palladian convent (Rooms 11 and 10). In 1828 both these halls were built, and the first one was opened; the second was not completed until 1834. In 1829 Lazzari completely remodeled the convent: in the courtyard he destroyed the arches inspired by Palladian perspective and left intact by Selva, and expanded the ends with two intercolumniations. He reopened the curtained sections of the Ionic arches, while at a later time both these and the Doric arches were fitted with large windows. In 1830 the façade was also modified: the emblems of La Carità were

replaced with those of the Accademia, windows were opened in the niches, and a sculpture—now located at the Public Gardens—by Antonio Giacarelli, *Minerva Seated Upon the Adriatic Lion*, was placed at the top. Initially, the annexation to the Kingdom of Italy did not bring about large-scale changes, but from 1870 the school gradually became separate from the Accademia Galleries. This took place through various stages, including decrees in 1878 and 1879. The collection, entrusted to the supervision of the president of the Accademia, was officially delivered to him on January 15, 1881, while on March 13, 1882, definitive independence was sanctioned for both the school and the Accademia Galleries.

In 1895 the galleries were radically reconfigured by the director, Giulio Cantalamessa. By eliminating works by artists of the 1800s and consolidating the few paintings from other Italian and foreign schools, he tried for the first time to establish a chronological order. The unitary cycles from the fifteenth-century schools of San Giovanni Evangelista and Sant'Orsola—previously spread out—were regrouped into two rooms of the church. Sixteenth-century Veneto paintings were placed in the corridors. He also removed the bronzes, which were later brought together again in the Franchetti Gallery at Ca' d'Oro. Cantalamessa thus established what has remained the primary focus of the Accademia: a collection of Veneto painting from the fourteenth to the eighteenth centuries. Cantalamessa was succeeded by Gino Fogolari in 1905, and little was done to the Accademia itself, although the collection of drawings and paintings continued to expand under his long direction. After World War I, Fogolari lobbied for important pieces of art which had originally belonged to Venice to be returned from Austria. During the war, the most important paintings had

been kept in Florence. From 1921 to 1923, as these pieces were being returned, the museum was again remodeled. The Accademia lost Titian's *Assumption*, which was returned to the Church of the Frari. The two rooms dedicated to the canvases of the "Ursula" cycle and the "Cross" cycle were eliminated, creating one large space with apses and restoring the truss ceiling and the Gothic windows on the side walls. As under the direction of Cantalamessa, once again the works from the nineteenth century were removed and placed in storage at Ca' Pesaro; a similar fate lay in store for the paintings from foreign schools, which were moved to the Franchetti Gallery. The need to implement more modern criteria for the museum reached its culmination during the 1940s, and especially when direction of the Accademia passed to Vittorio Moschini in 1941. Moschini worked with Carlo Scarpa, even while World War II was underway, to formulate a more articulate restructuring. The urgency to rebuild other Italian museums made it impossible to carry out the vast transformations that they had planned, but nonetheless a renovation project was begun which marked the end of a museum model that had remained unchanged since the turn of the century.

In 1994 a gallery was opened in the long wing of the Palladian hall on the second floor, increasing public access to more than eighty masterpieces of the collection. Maintenance work on the building, careful revision of all of the exhibit designs and intense restoration of the paintings have been realized in the last decades. Following the transfer of the Accademia di Belle Arti to the Ospedale degli Incurabili in 2005, major work has been carried out to double the exhibition spaces and endow the museum with all the modern facilities essential to its functioning.

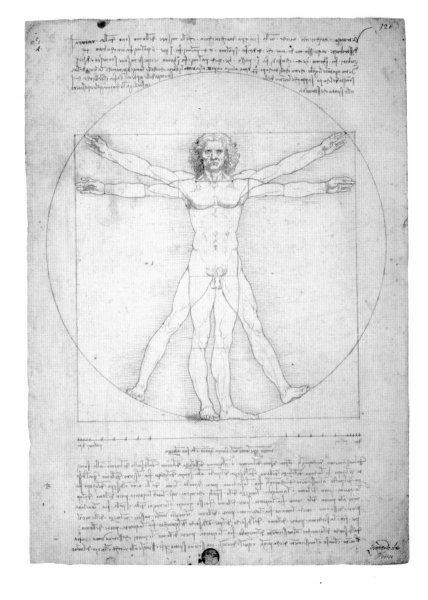

**Leonardo da Vinci**
*Vitruvian Man*

# 1 The Primitives

This was the room in which the chapter of the great Scuola di Santa Maria della Carità met, the oldest of the six great schools of Venice. These schools were powerful secular guilds for devotion and assistance to the poor. The ceiling, constructed between 1461 and 1484 by Marco Cozzi of Vicenza, is made up of square lacunars with leaf decorations on the side and heads of angels with eight wings, each with different facial characteristics. The blue background and the original colors of the figures have resurfaced from the gilt decoration made in the 1700s, thanks to a long restoration project completed in 1992. The paintings in the compartments, however, do not belong to the original decoration: at the center there is the *Holy Father*, probably the work of Pier Maria Pennacchi (1464–1514/1515), while at the corners there are the four Prophets attributed to Domenico Campagnola or Stefano dell'Arzere (documents dating from 1540 to 1575). The polychrome marble paving dates to the remodeling of the 1700s. The rooms underwent other modifications at the beginning of the 1800s, when the entire complex of buildings became the Accademia: the back altar was removed, the windows were walled over to increase exhibition space and the original paintings were replaced with works which were to form the new gallery (including Titian's *Assumption*, now in the Church of the Frari). The present-day configuration of the room is the work of Carlo Scarpa, which he began in 1950. He recovered the openings of the windows, restored the fragments of the late seventeenth-century pictorial mural decoration and placed the gold-ground panels on wooden partitions with iron bases still supporting them today. In this room are displayed works by Jacobello del Fiore, Paolo Veneziano, Lorenzo Veneziano, Giovanni da Bologna, Jacobello Alberegno, Catarino, Michele Giambono, Stefano "Plebanus" di Sant'Agnese, Antonio Vivarini, Nicolò di Pietro, Jacopo Moranzone, the Veneto-Byzantine school of the fourteenth and fifteenth centuries, the Venetian school of the second half of the fourteenth century, the Veneto school of the end of the fourteenth century, and the Rimini school.

**Paolo Veneziano**
active from 1333 to 1358;
died before 1362
*Polyptych*
Panels, gold ground
98 × 63 cm (central),
94 × 40 each (four sides),
26 × 19 (above six
larger panels),
23 × 7 (above four
smaller panels),
30 × 16 (the two top panels)
Acquisition: 1812,
1950 for the central panel
(cat. 21)
Latest restoration: 1951

At the center, the Coronation
of the Virgin. At the sides, the
stories of Christ. On the upper
crowning, to the left: the
Pentecost, Saint Matthew,
the veil-taking ceremony of
Saint Claire, Saint John, Saint
Francis gives back his clothes
to his father; to the right,
the stigmate of Saint Francis,
Saint Mark, the death of Saint
Francis, Saint Luke, Christ the
Judge. At the center: the two
prophets Isaiah and Daniel.
Dating to around 1350,
this work came from
the church of Santa Chiara.

**Lorenzo Veneziano**
records from 1356 to 1372
*Annunciation* (*Lion Polyptych*)
Panel, gold ground,
lower order:
126 × 75 cm (central),
121 × 60 (sides);
upper order: 82 × 83 (central),
67 × 30 (eight sides),
35 × 5 cm (thirty-six small
panels on the pillars)
Acquisition: 1812 (cat. 10)
Latest restoration: 1997

To the left, Saints Anthony
(Abbot), John the Baptist,
Paul and Peter. To the right,

Saints John the Evangelist,
Magdalene, Dominic and
Francis. On the upper order,
the Holy Father giving
his blessing among eight
Prophets. Below, on the
predella, the Hermit Saints
Saba, Macarius, Paul, Hilary
and Theodore. From the
high altar of the demolished
church of Sant'Antonio
di Castello, it bears the date
1357 and the donor's name.
The upper panel in the center
is a replacement of the lost
original, and is possibly
by Benedetto Diana.

**Room 1**

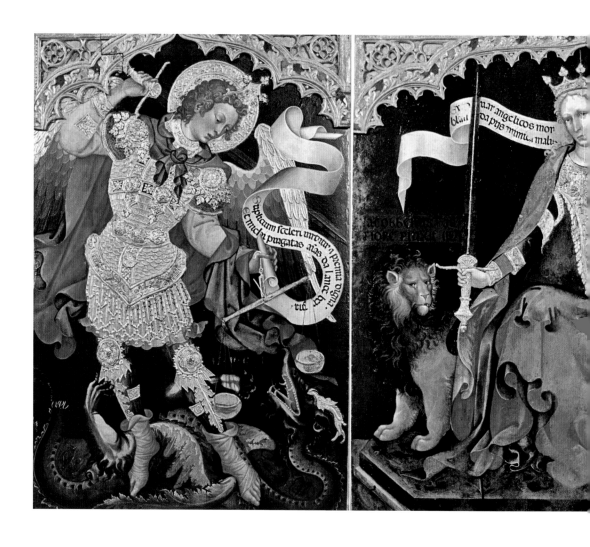

**Jacobello del Fiore**
records in Venice
from 1401 to 1439
*Justice and the Archangels
Triptych*
Panels with gilded
pastiglia decoration,
208 × 194 cm (central),
208 × 133 (Saint Michael)
208 × 163 (Saint Gabriel)
Acquisition: 1884
(cat. 15)
Latest restoration: 2007

At the center, the allegory
of Justice. To the left,
Saint Michael Slaying
the Dragon—a symbol
of Satan. To the right,
the Archangel Gabriel as
the angel of the Annunciation.
In the painting, which was
probably completed in 1421
for the Magistrato del Proprio
in the Doge's Palace, there
is a clear identification
of Justice with Venice
and with the Virgin Mary.

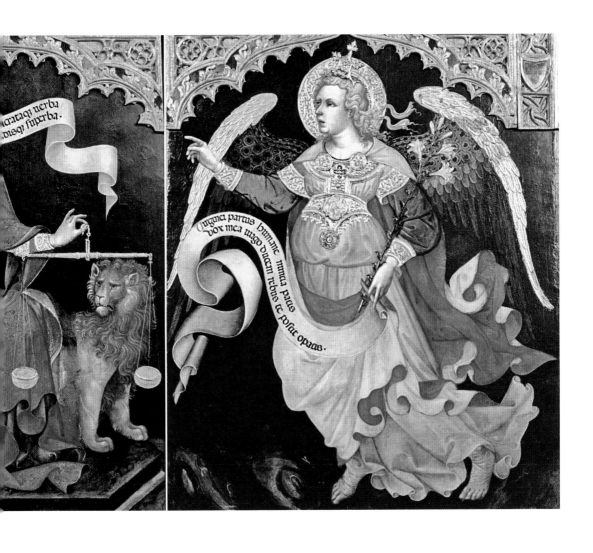

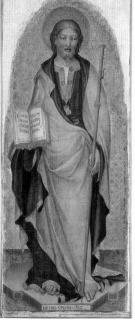

**Michele Giambono**
records from 1420 to 1462
*Saint James and Saints*
Panel, gold ground,
108 × 45 cm (central),
88 × 29 (sides)
Acquisition: 1812
(cat. 3)
Latest restoration: 1979

Dated at around 1450,
the polyptych is believed
to come from the church
of San Giacomo on the island
of Giudecca. The elegant
play of the lines—especially
evident in the figure
of Saint Michael—expresses
the decorative taste typical
of the late-Gothic style of
painting which Giambono
practiced in Venice.

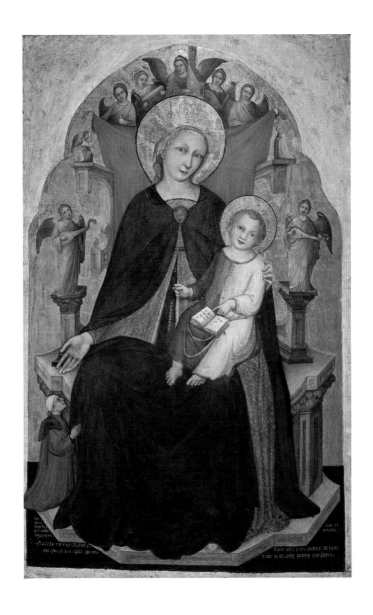

**Nicolò di Pietro**
records from 1394 to 1427
*Madonna and Child*
Panel, gold ground,
100 × 66 cm
Acquisition: 1856
(cat. 19)
Latest restoration: 1949

Under the footboard of the throne the date 1394, the name of the commissioner—kneeling to the left—and the signature of the artist and his address at the foot of the Ponte del Paradiso. In this first known and dated work of Nicolò di Pietro, there are many clear references to the Bolognese figurative style.

**Room 2** This room was constructed between 1886 and 1895 to house Titian's *Assumption* and other large altarpieces. After the *Assumption* was returned to the church of the Frari in 1919, the room appeared rather out of balance. To restore the room's harmony, in 1951 Carlo Scarpa replaced the decorated ceiling with a dark green plaster, and the polychrome marble paving with a dark grey Venetian style "terrazzo," masked the entrance by a large masonry panel and created a new stairway to Room 3. In this room are shown works by Vittore Carpaccio, Marco Basaiti, Giovanni Bellini and Giambattista Cima da Conegliano.

**Room 3** In this room are shown paintings by Sebastiano Luciani (del Piombo), Giambattista Cima da Conegliano, Giovanni Bellini and Giorgione.

**Giovanni Bellini**
(Venice 1434/39–1516)
*Madonna and Child Enthroned between Saints Francis, John the Baptist, Job, Dominic, Sebastian, Louis and Angels,* known as the *San Giobbe Altarpiece*
Panel, 471 × 292 cm (cat. 38)
Acquisition: 1815
Latest restoration: 1994–95

Originally in the church of San Giobbe, on the altar of the title saint (Job), which was second to the right. The great panel is shortened by 50 centimeters at the top. The presence of apotropaic Saint Sebastian indicates that the altarpiece, a fundamental masterpiece in Venetian painting, must have been made at the time of one of the plagues, probably that of 1478.

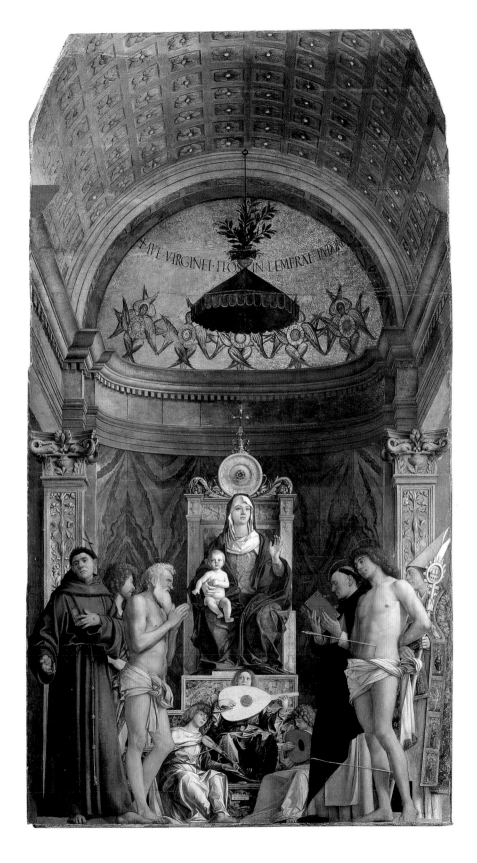

AVE VIRGINEI · FLOS IN LEMERAE INDOR

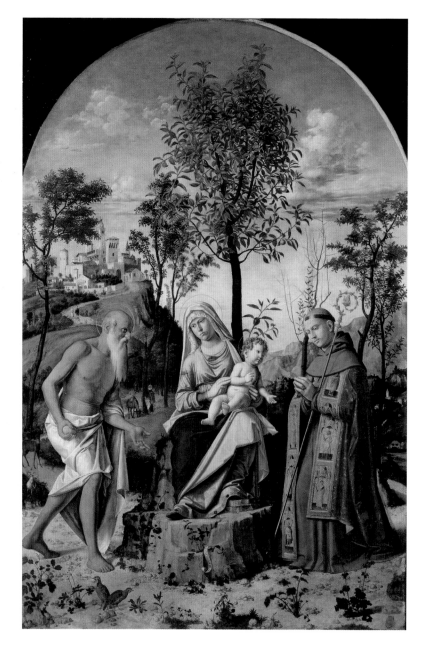

**Giambattista Cima da Conegliano**
(Conegliano 1459–1517)
*Madonna of the Orange Tree*
Panel, 211 × 139 cm
(cat. 815)
Acquisition: 1919
Latest restoration: 1995

This signed altarpiece was originally to the right of the main altar in the church of Santa Chiara on Murano. The theme is a variation on the *Flight into Egypt*, as is alluded to with Saint Joseph and the ass in the background. The work can be dated between 1496 and 1498.

**Vittore Carpaccio**
(Venice ca. 1460–before June 1526)
*Presentation of Christ in the Temple*
Panel, 420 × 231 cm
(cat. 44)
Acquisition: 1815
Latest restoration: 1995

Signed and dated 1510, the altarpiece was originally in the Church of San Giobbe in the third altar to the right.

Jesus' Presentation in the Temple—forty days after his birth—occurs in a space in the shape of an apse. Besides the extraordinary coloring, some of the details are splendid, including the female faces, inspired by the works of Perugino, and the three angels in the base playing the crumhorn, lute and lyre (*lira da braccio*).

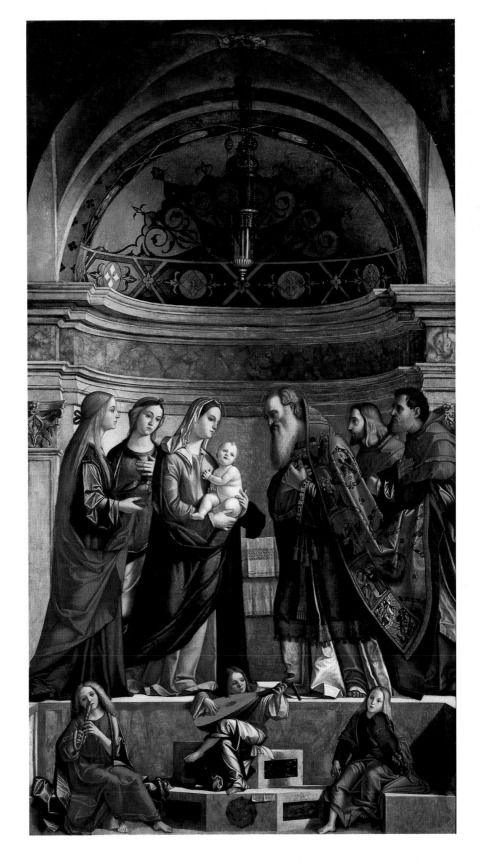

# **6** Titian, Jacopo Tintoretto and Paolo Veronese

In this room are displayed works by Tiziano Vecellio (Titian), Jacopo Robusti (Tintoretto) and Paolo Caliari (Veronese).

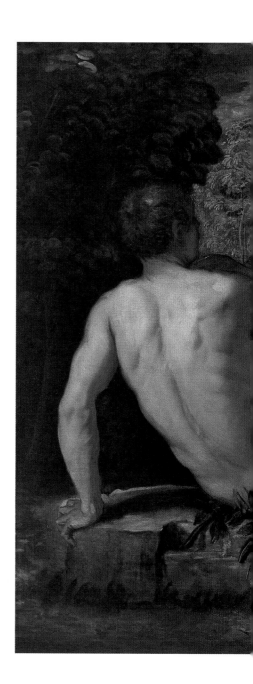

**Jacopo Robusti (Tintoretto)**
(Venice 1519–1594)
*The Temptation of Adam and Eve*
Canvas, 150 × 220 cm
(cat. 43)
Acquisition: 1812
Latest restoration: 1967

This work, together with the *Creation of the Animals* and *Cain and Abel*, created sometime between 1550 and 1553, was originally in the Scuola della Trinità. Adam and Eve are captured just before the consummation of their sin; to the right the sin has already been committed and the two progenitors are chased out by the angel.

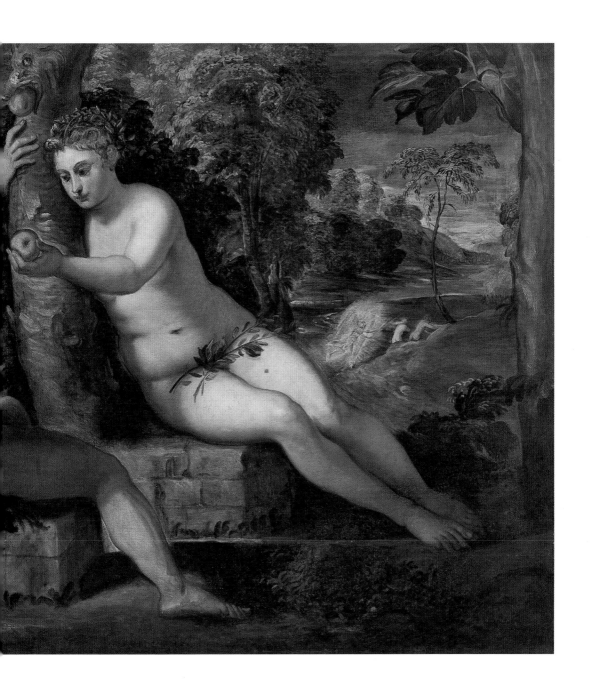

29                    **Room 6**

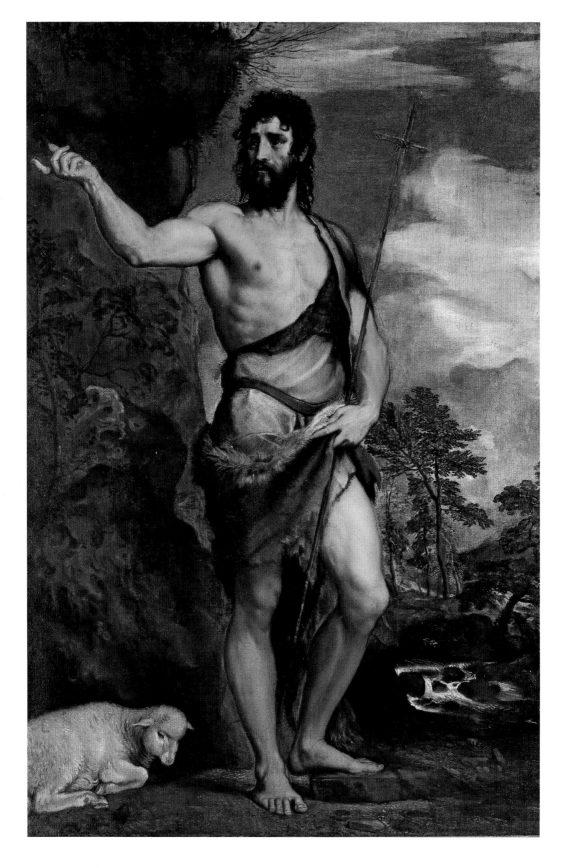

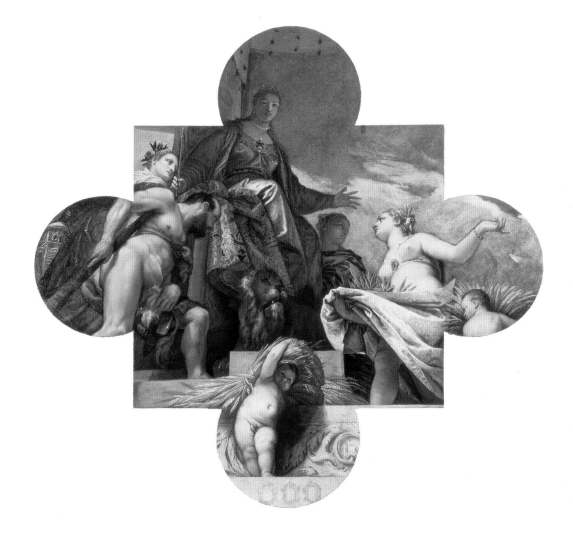

**Tiziano Vecellio (Titian)**
(Pieve di Cadore
ca. 1488/90–Venice 1576)
*Saint John the Baptist*
Canvas, 201 × 119 cm
(cat. 314)
Acquisition: 1808
Latest restoration: 1981

Signed "Ticianus" on
the stone at the bottom,
this painting was originally
located in the church
of Santa Maria Maggiore.
The figure of the saint—from
the stunning preparatory
sketch—recalls both
Michelangelo and classical
art sources, while the
background landscape
is decidedly fresh and new.
It is datable to the
mid 1540s.

**Paolo Caliari (Veronese)**
(Verona 1528–Venice 1588)
*Venice Receives Tribute
from Hercules and Ceres*
Canvas, 308 × 327 cm
(cat. 45)
Acquisition: 1895
Latest restoration: 1986

When once kept in the
Doges Palace, in the
"Magistrato alle Biade,"
the painting was perhaps
rectangular. Dated at
around 1576–78, it is one
of the artist's fundamental
works due to the skillful
perspective, backlighting
effects and refined coloring.

# 7/8  Lorenzo Lotto, Romanino and Jacopo Palma il Vecchio

In these rooms are displayed works by Giovanni Busi (Cariani), Antonio Badile, Giovanni Girolamo Savoldo, Alessandro Bonvicino (il Moretto), Bernardino Licinio, Lorenzo Lotto, Jacopo Negretti (Palma il Vecchio), Tiziano Vecellio (Titian), Bonifacio de' Pitati (Bonifacio Veronese), Giorgio Vasari, Andrea Previtali, Girolamo Romani (il Romanino) and the sixteenth-century Venetian school.

**Lorenzo Lotto**
(Venice ca. 1480–Loreto 1556)
*Portrait of a Gentleman in His Study*
Canvas, 97 × 110 cm
(cat. 912)
Acquisition: 1930
Latest restoration: 1997

Dating about 1528, this is one of the most famous portraits by Lotto. The young man is captured as a thought distracts him from his reading; his pallid face emerging from the darkness reveals a psychological intensity that foreshadows modern portraiture.

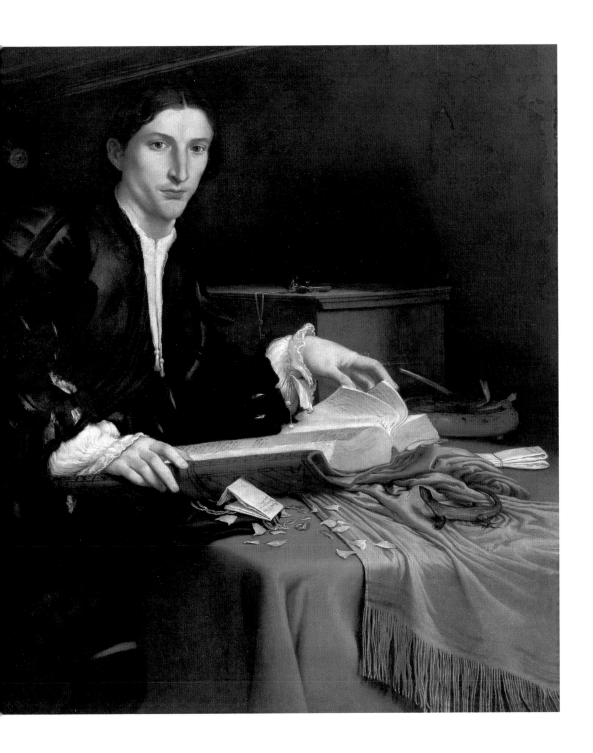

# 10 Titian, Japopo Tintoretto and Paolo Veronese

Begun by Francesco Lazzari in 1828,
the room was inaugurated in 1834.
The passage between this room and its twin
hall (Room 11) is decorated with four columns
in Greek marble from the Scuola di Santa
Maria della Misericordia.
In this room are shown works by Paolo Caliari
(Veronese), Jacopo Robusti (Tintoretto)
and Tiziano Vecellio (Titian).

**Paolo Caliari** (**Veronese**)
(Verona 1528–Venice 1588)
*Christ in the House
of Levi*
Canvas, 560 × 1309 cm
(cat. 203)
Acquisition: 1815
Latest restoration:
1980–82

This great painting was
originally a *Last Supper*
for the refectory of the
convent of Santi Giovanni
e Paolo, as a replacement
for a *Last Supper* by Titian
which had been lost in a fire.
The artist was accused
of heresy for this vast
composition which contained
what were considered to be
excessively anticonformist

elements. Veronese was
ordered to "amend" the
painting, in line with
canonical tradition. But the
only change he made was to
append the writing on the top
of the pillar with the date 1573
at its bottom, changing the
subject to the *Feast in the
House of Levi* (Luke, V), who,
being a Publican, could receive
a mixed crowd at his table.

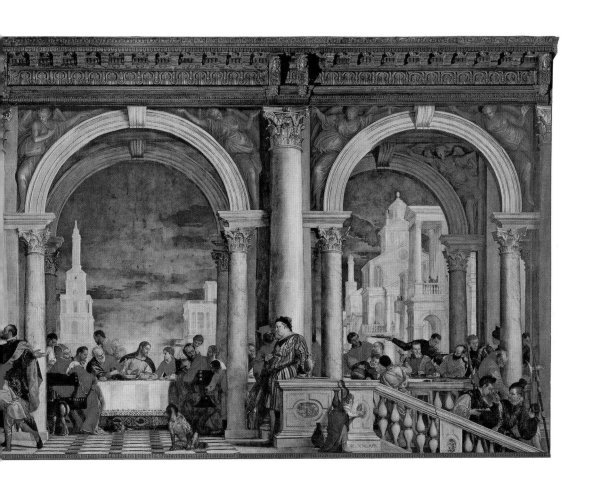

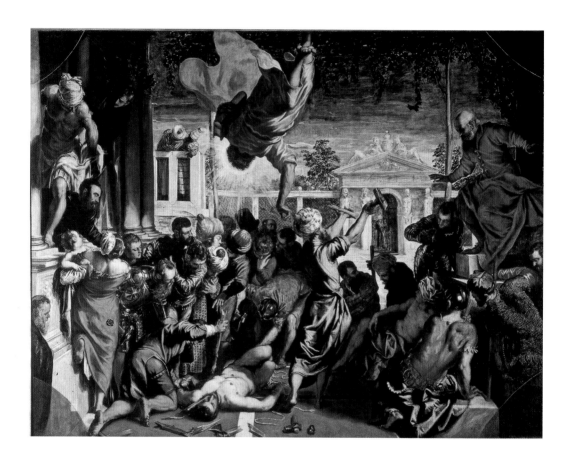

**Jacopo Robusti (Tintoretto)**
(Venice 1519–1594)
*Miracle of Saint Mark*
*Freeing the Slave*
Canvas, 416 × 544 cm
(cat. 42)
Acquisition: 1821
Latest restoration: 1965

This was the first painting made by Tintoretto for the Assembly Hall of the Scuola Grande di San Marco. It was probably commissioned in 1547 and completed by April of 1548 when Aretino, writing to Tintoretto, praised it. The scene is that of a slave being freed as a result of the

intercession of Saint Mark: he had been sentenced to be blinded and his limbs broken because, against his master's will, he had gone to worship the saint's relics.

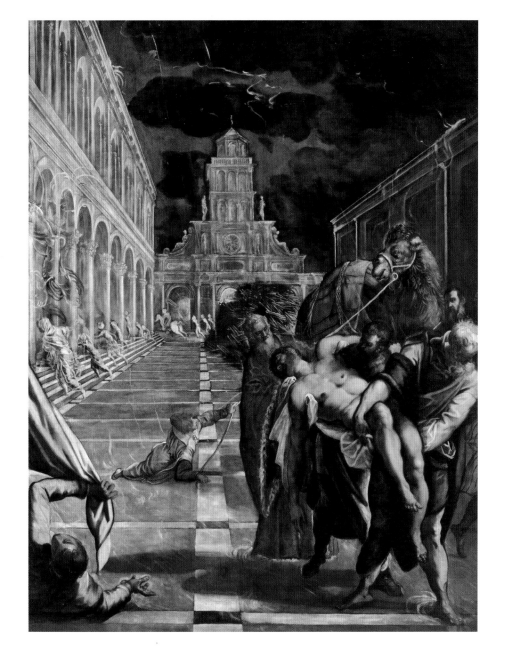

**Jacopo Robusti (Tintoretto)**
(Venice 1519–1594)
*Transport of the Body
of Saint Mark*
Canvas, 397 × 315 cm
(cat. 631)
Acquisition: 1920
Latest restoration: 1991–92

Painted between 1562
and 1566 for the Scuola
Grande di San Marco, this
work documents Tintoretto's
imaginative and evocative
style, and reveals the new
"luminismo" which typifies
Tintoretto's paintings from
this period. It represents,
according to the legend,

the episode during which two
Venetian tradesmen, owing
to a sudden storm, were
able to remove Saint Mark's
body that was about
to be burned at the stake.

**Room 10**

**Paolo Caliari (Veronese)**
(Verona 1528–Venice 1588)
*The Marriage*
*of Saint Catherine*
Canvas, 377 × 241 cm
(cat. 1324)
Acquisition: 1918
Latest restoration: 1986

Painted for the main altar
of the Venetian Church
of Santa Caterina. Dated
around 1575, near the time,
when Veronese painted
the canvases for the ceiling
of the Collegio Hall in the
Doge's Palace. It represents

Catherine of Alexandria's
allegorical nuptials with
Jesus, the only person worthy
of being the spouse of a king's
daughter, of great beauty
and precocious wisdom.

**Titian**
(Pieve di Cadore ca.
1488/90–Venice 1576)
*Pietà*
Canvas, 353 × 347 cm
(cat. 400)
Acquisition: 1814
Latest restoration: 2008

The painting, made up
of seven pieces of canvas
of different types and
thicknesses, was conceived by
Titian, as recorded by Ridolfi
in 1648, for the chapel of
Christ in the Frari church
in exchange for permission
to be entombed there.
And here it was in fact
exhibited, as recorded in a
document from March 1575
from the Vatican's Secret
Archives, in which a decree of
the papal nuncio to the Frari
orders that the picture should

be returned to the artist
after it had been moved
to a different altar from
the one agreed upon.
On its return to the bottega,
it must have been revised
by Titian, who transformed
it the following year, when
the plague was at its
height, into an immense
ex-voto, even before grace
received. In it he depicted
himself twice as genuflecting
before Mary and her Son,
once in the guise of Saint
Jerome and again in the

votive tablet on the right,
a painting within the
painting. After his death
on August 27, 1576 the work,
with the approval of the
Republic, was delivered to
Jacopo Palma the Younger,
who added the finishing
details and the inscription:
"quod Titianus inchoatum
reliquit / Palma reverenter
absolvit deoq dicavit opu"
("what Titian left unfinished,
Palma completed with
reverence and dedicated
the work to God").

**Room 10**

# 11 Bonifacio Veronese, Jacopo Tintoretto, Bernardo Strozzi and Giambattista Tiepolo

In this room are shown works by Leandro da Ponte (Bassano), Bernardo Strozzi, Giambattista Tiepolo, Luca Giordano, Jacopo Robusti (Tintoretto), Bonifacio de' Pitati (Bonifacio Veronese), Giovanni Antonio de' Sacchis (Pordenone).

**Bonifacio de' Pitati (Bonifacio Veronese)**
(Verona 1487–Venice 1553)
*The Wealthy Epulon*
Canvas, 206 × 438 cm
(cat. 291)
Acquisition: 1812
Latest restoration: 1991–92

Dated around 1543–45, this is the artist's masterpiece. The episode of Epulon refusing to give alms to poor Lazarus becomes the pretext for an extraordinary description of Venetian villa life.

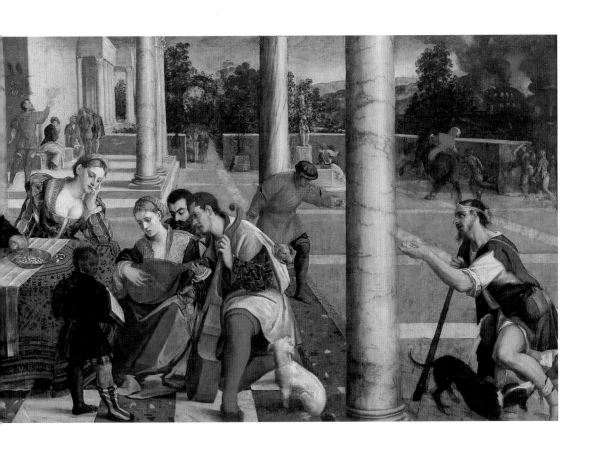

**Room 11**

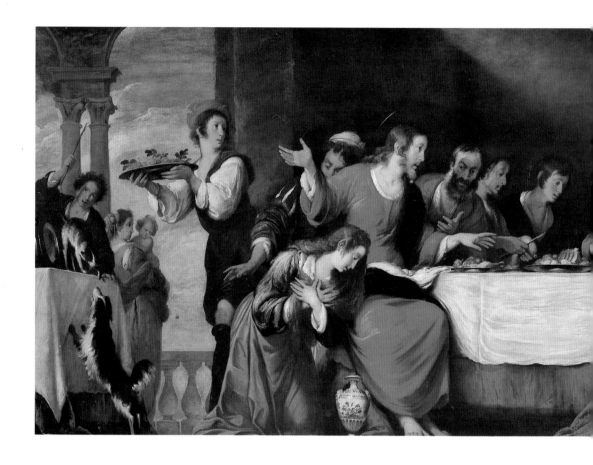

**Bernardo Strozzi**
(Genoa 1581–Venice 1644)
*Feast in the House of Simon*
Canvas, 257 × 737 cm
(cat. 777)
Acquisition: 1911
Latest restoration: 1981

This large painting from the chapel of Palazzo Gorleri in Genoa must have been originally been made for the visitor's room in the monastery of Santa Maria in Passione. It reveals a distinct Venetian influence, a style well known to Strozzi even before he moved to Venice. It can be dated to the 1620s.

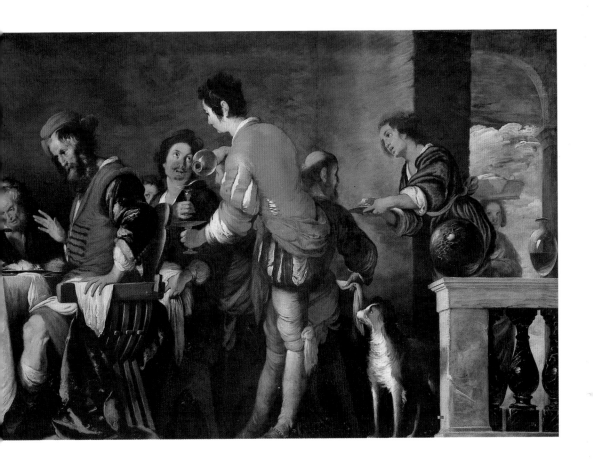

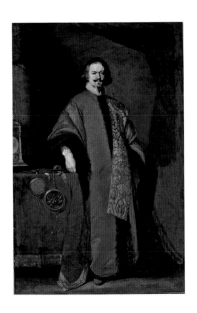

**Bernardo Strozzi**
(Genoa 1581–Venice 1644)
*Portrait of the Knight
Giovanni Grimani*
Canvas, 225 × 143 cm
(cat. 1358)
Acquisition: 1981
Latest restoration: 1995

Giovanni Grimani, while he
was ambassador in Vienna
from 1636 to 1640, was
knighted by the Emperor.

It is likely that this portrait
was commissioned on
his return from Vienna,
immediately after 1640.
Grimani is portrayed with the
golden stole, symbol of the
knighthood. This work is a
masterpiece from the height
of Strozzi's artistic maturity.
Hints of Rubens and Van
Dyck are brought together
with a typically Venetian
treatment of light and color.

**Room 11**

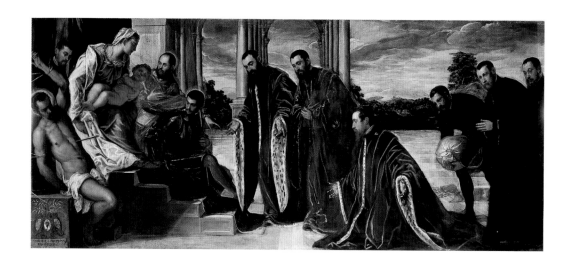

**Jacopo Robusti**
**(Tintoretto)**
(Venice 1519–1594)
*Madonna dei Camerlenghi*
Canvas, 221 × 520 cm
(cat. 210)
Acquisition: 1883
Latest restoration: 1992

This large painting,
also known as the
"Madonna dei Tesorieri,"
was made in 1567 for Palazzo
Camerlenghi at the Rialto.
It is a masterpiece
of the Venetian votive
painting tradition.

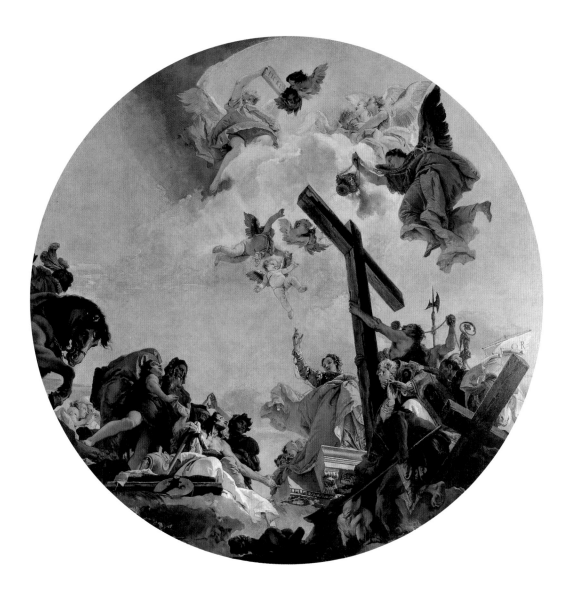

**Giambattista Tiepolo**
(Venice 1696–Madrid 1770)
*Discovery of the True Cross*
Canvas, diameter 500 cm
(cat. 462)
Acquisition: 1812
Latest restoration: 1982

The large ceiling painting
was made for the church
of Le Cappuccine in Castello,
which was destroyed.
Close to the first works
delivered by Tiepolo in 1743
to the Scuola dei Carmini.
A sketch showing an early
idea for the painting is also
in the Accademia (cat. 789).

**Room 11**

# 12/13 Andrea Mantegna, Piero della Francesca, Cosmè Tura, Giovanni Bellini, Giorgione, Jacopo Bassano and Jacopo Tintoretto

**Room 12** The hall is made up of the long Palladian corridor, with its grand windows (probably dating back to Lazzari during the 1800s). In 1912, three doors were added with their oversections—perhaps taken from a palazzo in Brescia, as they are the work of Pietro Scalvini (Brescia 1718–1792) and Saverio Gandini (Cremona ca. 1729–Brescia 1796). In the door where the sculpture is depicted we can see the signature of Scalvini and the date 1778. The hall also displays works by Marco Ricci, Giuseppe Zais, Francesco Zuccarelli and Antonio Diziani.

**Room 13** Obtained by joining three rooms of the Carità convent, with the earliest restoration works, the ceiling of the first zone, which was decorated by Tranquillo Orsi, was uncovered after some years under a large canvas. In 1947, Carlo Scarpa undertook work on it. On display in the hall are works by Jacopo da Ponte (Bassano), Jacopo Robusti (Tintoretto) and, temporarily, a new installation of paintings by Piero della Francesca, Andrea Mantegna, Cosmè Tura, Giovanni Bellini, Giorgione.

**Jacopo Robusti (Tintoretto)**
(Venice 1519–1594)
*Procurator Jacopo Soranzo*
Canvas, 106 × 90 cm
(cat. 245)
Acquisition: 1812
Latest restoration: 1957

From the Procuratoria de Supra, the work was originally in the form of a lunette. Despite its official function for use in processions, the image, dating from about 1550, possesses an extraordinary expressive power.

**Cosmè Tura**
(Ferrara 1430-1495)
*Madonna and Child*
Panel, 61 × 41 cm
(cat. 628)
Acquisition: 1896
Latest restoration: 1982

A work of the founder of
fifteenth-century Ferrarese
painting school, dated
around 1470, this painting
was probably conceived
for a private residence,
as the inscription near
the bottom would indicate.
The presence of profane
elements in a sacred painting,
including references
to astrology, reflects
an intellectual custom
of the time and is recurrent
in Ferrarese painting.

**Andrea Mantegna**
(Isola di Carturo,
Padua 1431/32–Mantua 1506)
*Saint George*
Panel, 66 × 32 cm
(cat. 588)
Acquisition: 1856
Latest restoration: 1992

Dated about 1446, this
painting is believed to have
been the side panel of a
polyptych. The stern young
man—more mythical hero
than Christian saint—wears
a breastplate inspired by
a drawing of Jacopo Bellini,
Mantegna's father-in-law.

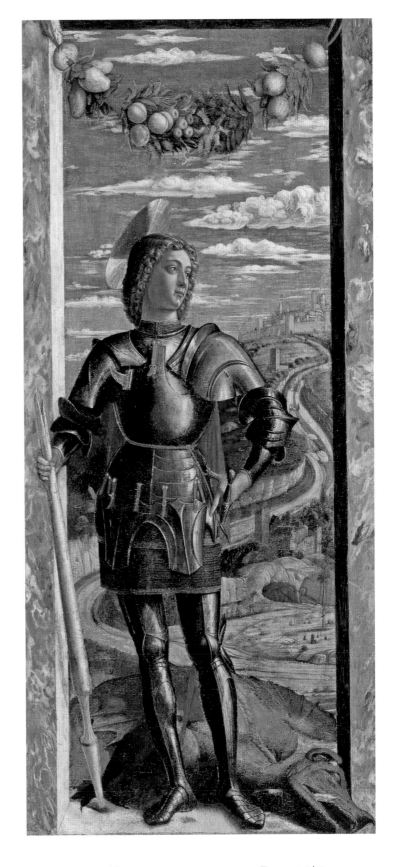

**Rooms 12/13**

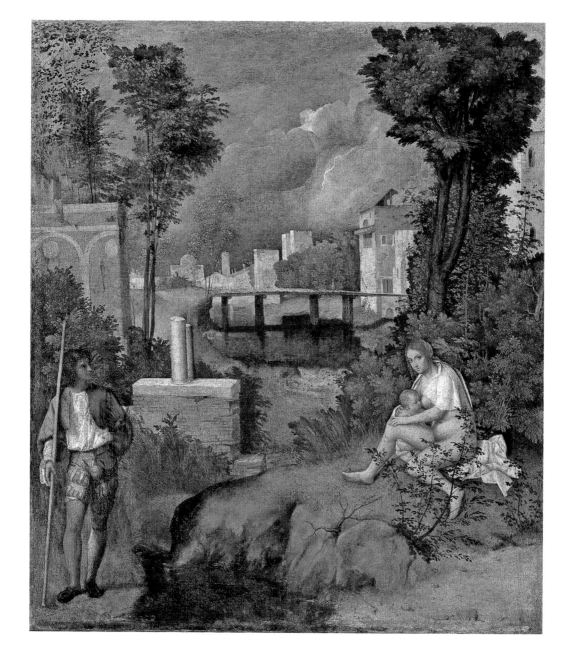

**Giorgione**
(Castelfranco 1476/77
–Venice 1510)
*The Tempest*
Canvas, 82 × 73 cm
(cat. 915)
Acquisition: 1932
Latest restoration: 1984

A private devotional work,
*The Tempest* has been
the source of countless
interpretations, from
mythological to allegorical
and even political. It has also
been seen as the melding of
many literary and figurative
sources, or even as a work
which would not require
any decoding whatsoever,
representing simply what
Michiel has suggested: a
"tempest" with a gypsy.
The dating is also difficult;
critics now tend to place it
around 1505–06.

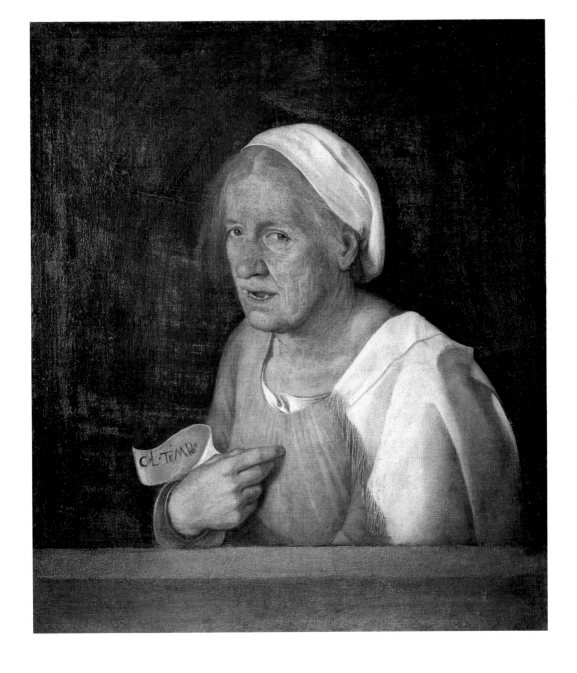

**Giorgione**
(Castelfranco 1476/77
–Venice 1510)
*The Old Woman*
Canvas, 68 × 59 cm
(cat. 272)
Acquisition: 1856
Latest restoration: 1984

The interpretation
of this work is extremely
controversial: it is clearly
an allegory, as the writing
on the scroll, "col tempo"
("with time"), would
indicate; but the symbolism
notwithstanding, it is
an extraordinary portrait
in its own right. It was
painted after *The Tempest*
in around 1508.

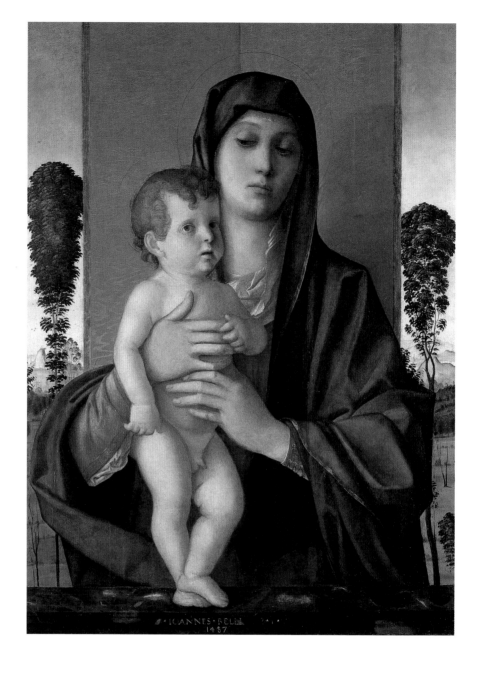

**Giovanni Bellini**
(Venice 1434/39–1516)
*Madonna degli Alberetti*
(*Madonna of the Trees*)
Panel, 71 × 58 cm
(cat. 596)
Acquisition: 1838
Latest restoration: 1998

The first dated work by
Giovanni Bellini (the date
1487 and Bellini's signature
can be seen near the bottom
in the center), this is one
of his most moving works
for private devotion.

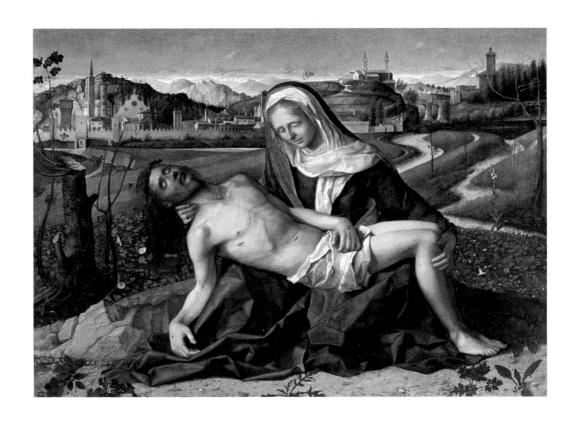

**Giovanni Bellini**
(Venice 1434/39–1516)
*Pietà*
Panel, 65 × 87 cm
(cat. 883)
Acquisition: 1934
Latest restoration: 1996

A work commissioned for
private use, Bellini's *Pietà*
dates to the beginning
of the sixteenth century and
is signed near the bottom
on the left side. Rich with
religious symbolism, the
landscape brings together
edifices of various origin
in suggestive synthesis.

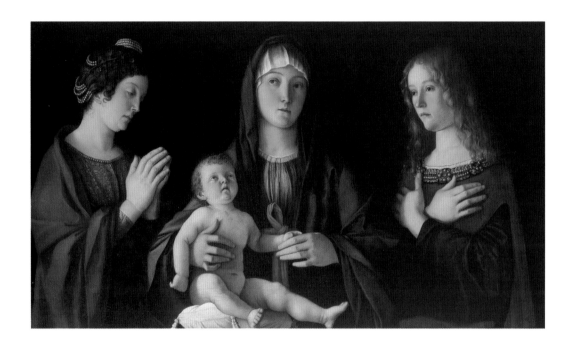

**Giovanni Bellini**
(Venice 1434/39–1516)
*Madonna and Child
with Saints Catherine
and Magdalene*
Panel, 58 × 107 cm
(cat. 613)
Acquisition: 1850
Latest restoration: 1997

Dated around 1500, this
painting reflects the influence
of Leonardo in its treatment
of the relationship between
background and subject.
Dressed with refined
elegance, the two saints
seem more like two Venetian
patricians than celestial
creatures.

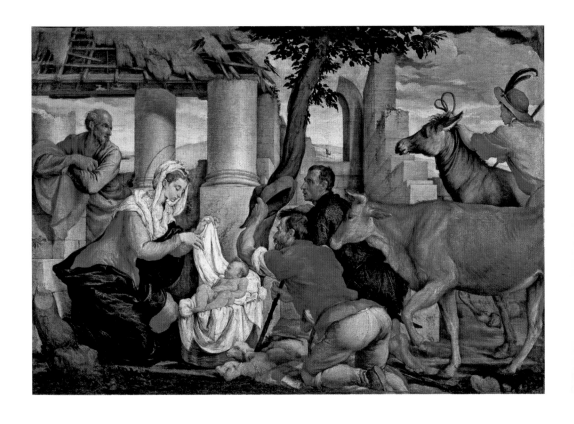

**Jacopo da Ponte (Bassano)**
(Bassano 1517–1592)
*Adoration of the Shepherds*
Canvas, 95 × 140 cm
(cat. 1360)
Acquisition: 1983

In this composition, which
evokes Titian-like themes,
there is a unique blend
of Parmigianino influences,
Mannerist refinement and
naturalistic observations.
It dates to 1545 or just after.

# 14 Seventeenth-Century Paintings

This room underwent the same
changes and renovations as Room 13.
In this room are shown works by
Annibale Carracci, Bernardo Strozzi,
Pierfrancesco Mola, Domenico Fetti,
Johann Liss, Tiberio Tinelli, an anonymous
seventeenth-century painter, Mattia Preti,
an imitator of Giambattista Langetti,
Sebastiano Mazzoni, Francesco Maffei,
Pietro Muttoni (Della Vecchia)
and Giulio Carpioni.
The room is temporarily closed.

**Domenico Fetti**
(Rome (?) 1588/89–Venice
1623)
*David*
Canvas, 175 × 128 cm
(cat. 669)
Acquisition: 1838
Latest restoration: 1996

The painting dates from
between 1617 and 1619,
prior to when the artist
resided in Venice. The young
man, with his suffering
beauty and contemporary
dress, recalls the Caravaggio's
elegant knights.

**Domenico Fetti**
(Rome (?) 1588/89–Venice
1623)
*Meditation*
Canvas, 179 × 140 cm
(cat. 671)
Acquisition: 1838
Latest restoration: 1961

This famous painting
is believed to have been
completed around 1618,
before the artist resided
in Venice. The female figure is
situated between the still life
of the lower part of the
painting alluding to death
and the "sadness of the
world." The grapevine above
symbolizes life and salvation.

**Room 14**

# 15 Giovanni Antonio Pellegrini, Giambattista Tiepolo and Giannantonio Guardi

This is the final part of the long Palladio corridor. The "cell" structure (Rooms 16 and 16a) is to the left, while within the building itself is a large exhibition space that was created from joining three rooms (into Room 17); a door remains from one of these rooms. Towards the rear, through the large doorway is found the famous oval stairway designed by Palladio in 1561. This room displays works by Giambattista Tiepolo, Francesco Solimena, Giambattista Pittoni, Giannantonio Guardi, Giovan Antonio Pellegrini, Angelo Trevisani, Giandomenico Tiepolo and, temporarily, Pietro Longhi.

**Pietro Longhi**
(Venice 1701–1785)
*The Apothecary*
Canvas, 59 × 48 cm
(cat. 467)
Acquisition: 1838

With the artist's signature on the back, this is probably his most famous painting. The interior evokes with extraordinary success an eighteenth-century apothecary shop. It is from around the same time as *The Rhinocerous* (Ca' Rezzonico), 1751.

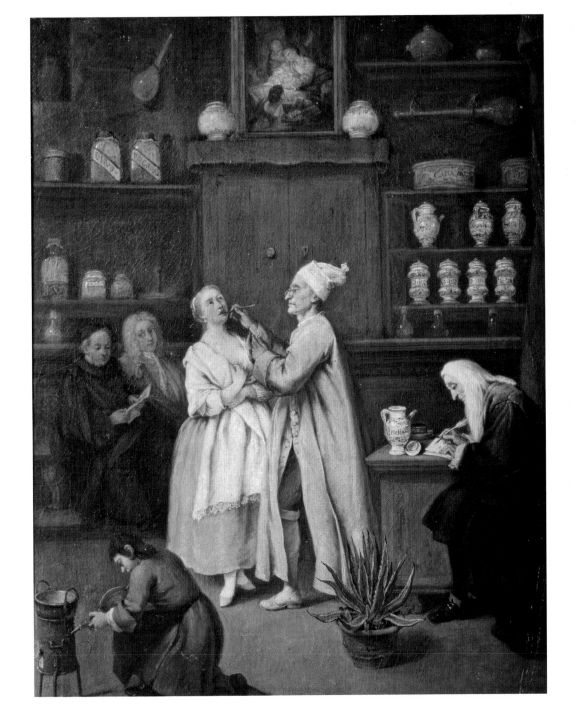

**Room 15**

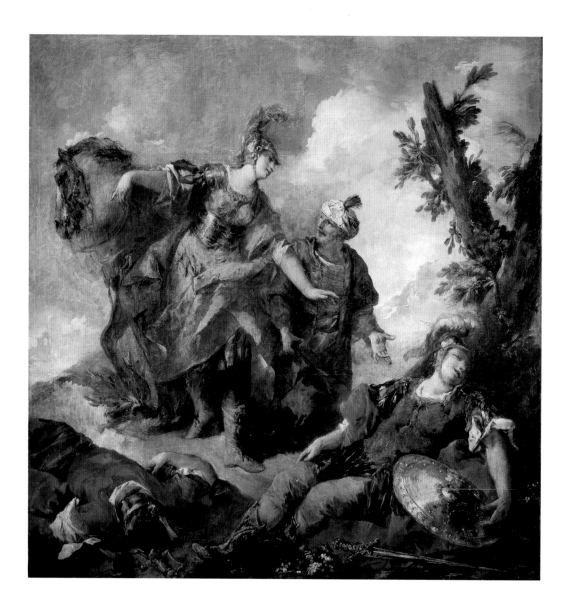

**Giannantonio Guardi**
(Vienna 1699–Venice 1760)
*Herminia and Vaprinus
Happen Upon the Wounded
Tancredi after His Duel
with Argante*
Canvas, 250 × 261 cm
(cat. 1387)
Acquisition: 1988

This is the only work by
the artist at the Accademia,
and was probably part
of a cycle of thirteen
paintings inspired by
Tasso's *Jerusalem Delivered*,
with engravings by Piazzetta.
It is dated around 1750–55,
at the height of his maturity.

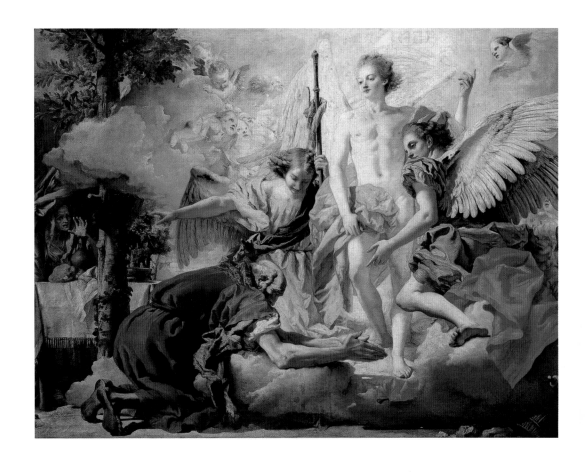

**Giandomenico Tiepolo**
(Venice 1727–1804)
*Abraham and the Angels*
Canvas, 200 × 281 cm
(cat. 834)
Acquisition: 1807
Latest restoration: 2008

This is the last painting
commissioned by the Scuola
della Carità to complete
the decoration of the new

Chancellery which
was erected in 1764.
Giandomenico won the
competition and in 1773
undertook to paint the work.
Three of his preparatory
drawings for Abraham are
held by the Correr Museum.
The smoothness of the color
and the cold purity of the
drawing are early reflections
of neoclassical thought.

**Room 15**

# 16/16a  Early Works by Giambattista Tiepolo, Alessandro Longhi, Giambattista Piazzetta and Fra' Galgario

The two halls maintain the original dimension of convent cell. Both were renovated in 1947 by Carlo Scarpa, who later, in 1959, went on to design the support for *The Fortune Teller* by Piazzetta. The rooms also display works by Sebastiano Ricci, Giambattista Tiepolo, Giuseppe Angeli, Giambattista Piazzetta, Vittore Ghislandi (Fra' Galgario), Giuseppe Nogari, Alessandro Longhi and, temporarily, Rosalba Carriera, Canaletto, Francesco Guardi, Bernardo Bellotto.

**Giambattista Piazzetta**
(Venice 1683–1754)
*The Fortune Teller*
Canvas, 154 × 115 cm
(cat. 483)
Acquisition: 1887
Latest restoration: 1983

This painting, among the most famous by Piazzetta, is universally called *The Fortune Teller*, but its interpretations vary widely: it can be seen politically, symbolically or even as an amorous initiation of the two youths to the right. On the back of the original canvas is a folio with the date 1740.

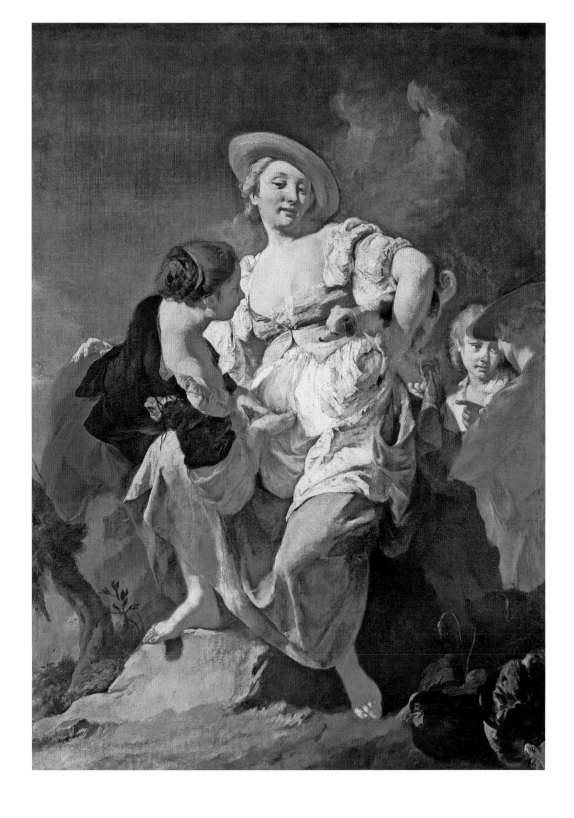

**Rooms 16/16a**

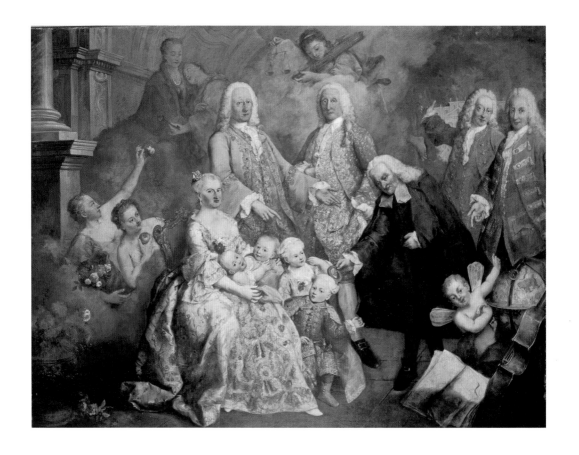

**Alessandro Longhi**
(Venice 1733–1813)
*The Family of Procurator*
*Luigi Pisani*
Canvas, 255 × 340 cm
(cat. 1355)
Acquisition: 1979
Latest restoration: 1996

Doge Alvise Pisani
(1664–1741) is shown with
his son Luigi the Procurator,
his wife Paolina Gambara
and four children,
surrounded by allegorical
figures symbolizing
family virtues. In the
background are probably
two of Pisani's other
children. The figure
in black may be Abbot
Giovanni Gregoretti.
Painted in 1758.

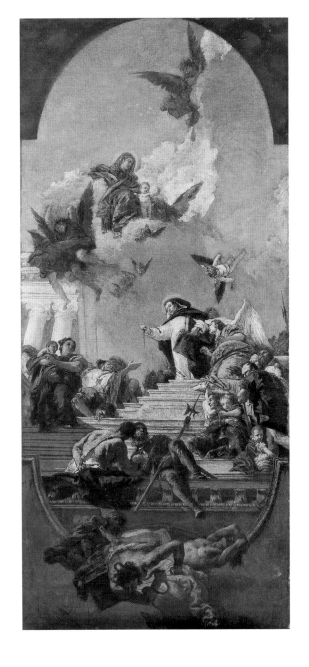

**Giambattista Tiepolo**
(Venice 1696–Madrid 1770)
*Institution of the Rosary*
Canvas, 108 × 51.5 cm
(cat. 2041)
Acquisition: 2006

The work, formerly
the property of the Crespi
collection in Milan, is one
of three preparatory
sketches for the central

fresco in the vault of Santa
Maria del Rosario (Gesuati)
in Venice, where Tiepolo
worked between 1737 and
1739. The subject celebrates
two moments in the life
of Saint Dominic: his
reception of the Rosary
from the hands of the Virgin
and the start of his Marian
preaching.

**Rooms 16/16a**

**Rosalba Carriera**
(Venice 1675–1758)
*Portrait of a Young Man*
Paper, 34 × 27 cm
(cat. 445)
Acquisition: 1888

This work dating from 1726 is undoubtedly a portrait of the son of the French consul Le Blond, and reveals an image of exquisite grace and gentleness.

**Rosalba Carriera**
(Venice 1675–1758)
*Self Portrait*
Paper, 31 × 25 cm
Acquisition: 1927

In this painting, which
was made by the artist a few
years before she fell victim
to "a total loss of reason,"
Carriera's face appears
pained and tired, almost
foreshadowing the real
blindness that would afflict
the painter in 1746.

**Antonio Canal (Canaletto)**
(Venice 1697–1768)
*Capriccio of a Colonnade*
Canvas, 130 × 92 cm
(cat. 463)
Acquisition: 1807
Latest restoration: 1985

Trial work of acceptance, after the artist was made professor of perspective architecture, signed and dated 1765. The *Capriccio* (or imaginary view), now famous, was copied many times by Canaletto himself.

**Bernardo Bellotto**
(Venice 1721–Warsaw 1780)
*Rio dei Mendicanti and the Scuola di San Marco*
Canvas, 41 × 59 cm
(cat. 494)
Acquisition: 1856
Latest restoration: 1990

Largely attributed to Bellotto during his apprenticeship in the studio of his uncle, Canaletto, the work dates to around 1740.

**Rooms 16/16a**

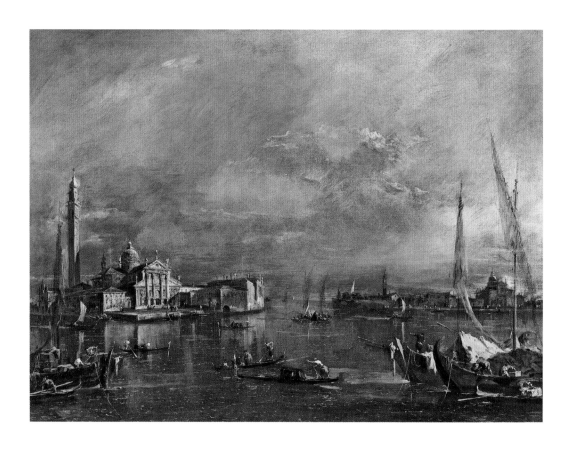

**Francesco Guardi**
(Venice 1712–1783)
*St. Mark's Basin with*
*San Giorgio and Giudecca*
Canvas, 69 × 94 cm
(cat. 709)
Acquisition: 1903
Latest restoration: 1993

On the house at bottom left
the initials F.G. It is one
of the many versions
of a theme the artist often
painted. To the left the island
of San Giorgio Maggiore,
to the right Giudecca with
the now destroyed Church
of San Giovanni Battista.
The painting should not

be dated later than 1774,
the year in which the
bell tower in San Giorgio
suddenly collapsed; we see
it here with its original
"onion" cupola.

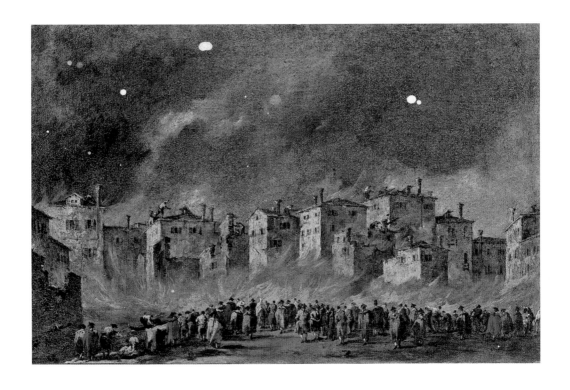

**Francesco Guardi**
(Venice 1712–1793)
*Fire at San Marcuola*
Canvas, 32 × 51 cm
(cat. 1344)
Acquisition: 1972
Latest restoration: 1993

This is Guardi's rendering
of a real event: the dramatic
fire at the oil storehouse in
the Ghetto, which occurred
on November 28, 1789.
It is among the artist's
masterpieces within the
documentary style,
composed towards his
late maturity.

# 19/20 Bartolomeo Montagna, Giovanni Agostino da Lodi, Boccaccio Boccaccino and "Stories of the Relic of the Cross"

**Room 19** This is a corridor which connects with Rooms 20 and 21, showing fifteenth-century "story" cycles. The platform at the back with the sash window from which one can admire the view of the Palladio convent, was designed by Carlo Scarpa in 1947. In this room are shown works by Giovanni Agostino da Lodi, Pietro de Saliba (?), Antonello de Saliba, Marco Basaiti, Bartolomeo Cincani (il Montagna), Jacopo Parisati (da Montagnana), Boccaccio Boccaccino, Marco Marziale and Vittore Carpaccio.

**Room 20** This room was already constructed in 1940. Seven years later the canvases with the "Miracles of the Cross" were placed here provisionally; in 1959–60 Carlo Scarpa completed the arrangement which has remained unchanged since that time. The cycle originally served to adorn the walls of the Albergo Room or the Cross Room in the Scuola di San Giovanni Evangelista, where there is still a relic of the Holy Cross on display. There were originally ten canvases, including the *Miracle of the Vendramin Ships* by Pietro Perugino, completed in 1494. Unfortunately only eight are on display at the Accademia; Perugino's canvas—composed while he was in Venice working in the Doge's Palace—was destroyed and replaced in 1588. The most detailed source on this question is a pamphlet of 1590, which describes the "Miracles," giving the name of the author and the year of execution of the painting illustrating them. The Scuola di San Giovanni Evangelista was suppressed by Napoleonic decree in 1806, and the paintings were delivered to the Accademia in 1820; they were displayed separately at various times until they were finally reunited in 1947. In this room are shown works by Vittore Carpaccio, Gentile Bellini, Benedetto Rusconi (Diana), Lazzaro Bastiani and Giovanni Mansueti.

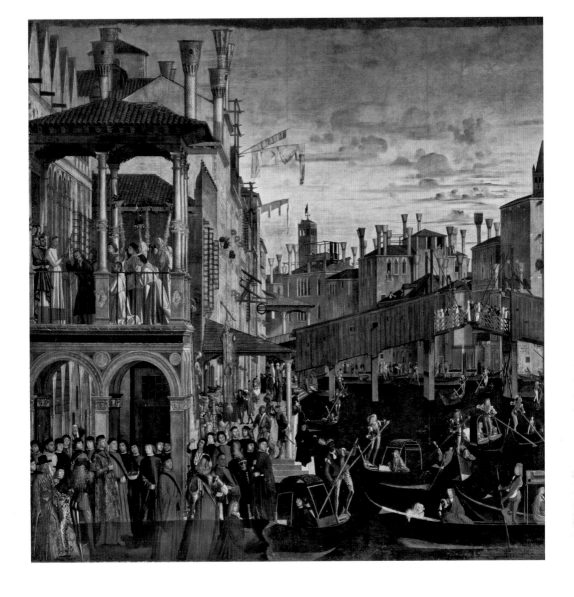

**Vittore Carpaccio**
(Venice ca. 1460–before
June 1526)
*Miracle of the Cross
at the Rialto*
Canvas, 371 × 392 cm
(cat. 566)
Acquisition: 1820
Latest restoration: 1990–91

This canvas, completed
in 1494, narrates the
miraculous healing
of a possessed man.
The artist synthesizes three
fundamental moments:
the procession on the bridge,
the entrance of the patriarch,
and the miracle which
takes place on the loggia.
But even this event is
overshadowed by the

representation of the city
itself. A comparison
with the analytical realism
of the other canvases
brings out even more
clearly their chromatic values
and descriptive power.

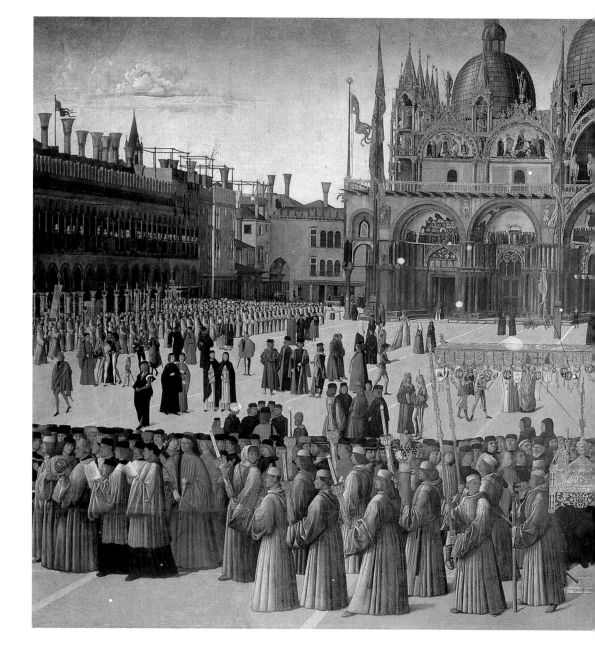

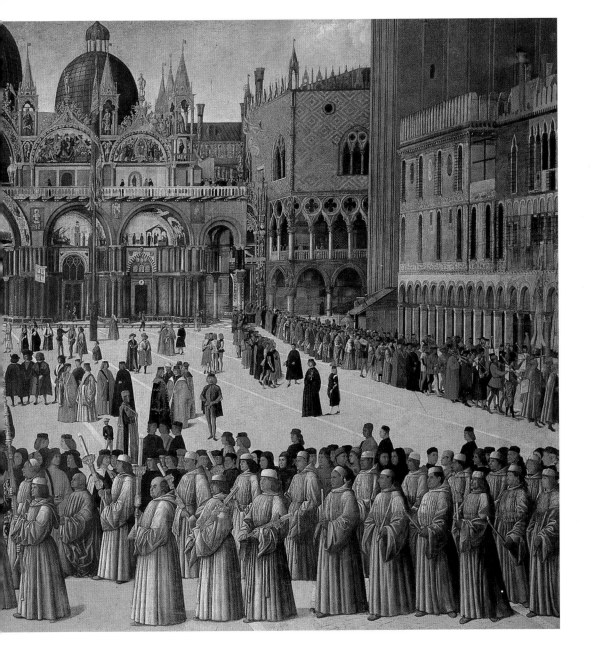

**Gentile Bellini**
(Venice 1429–1507)
*Procession in
Piazza San Marco*
Canvas, 373 × 745 cm
(cat. 567)
Acquisition: 1820
Latest restoration: 1988–89

At the bottom in the center of the painting can be read the date 1496 and the artist's signature. The painting depicts the procession taking place in Piazza San Marco on the Feast of Saint Mark. All the schools participated in this event with their respective relics, and, in particular, the episode which took place on April 25, 1444, when the Brescian merchant Jacopo de' Salis implored and obtained help for his son who was gravely injured. The procession is described with less attention than the square itself, however, which is shown here as it appeared before the changes made to it in the sixteenth century.

**Room 21** In this room, which once held the collection of Girolamo Contarini, the "Saint Ursula" Cycle by Carpaccio was installed between 1921 and 1923. From 1959–60 Carlo Scarpa remodeled the room, lowering the paintings, which were held up and surrounded by a strip of light oak with a subtle gilt border.

The altarpiece, set slightly back and illuminated from the side by a new source of light, was separated from the canvases with wooden screens. The works come from the Scuola di Sant'Orsola—today absorbed into the rectory of the Church of Santi Giovanni e Paolo, which in 1488 had decided to decorate its site with "the stories of Madonna Saint Ursula." Carpaccio composed nine paintings bearing dates from 1490 to 1495, but whose execution continued for several more years. The stylistic differences of the canvases—which have also undergone numerous restorations and changes—are attributed to the many assistants. In fact, the artist made wide use of preparatory cartoons which were placed in the canvas using the dusting system—a task partly shared by various assistants. Based on an affirmation in *De origine, situ urbis Venetie* by Marin Sanudo, who noted in 1493 that ... among the interesting things of this city is the chapel of Saint Ursula at San Zuanne Polo, and the beautiful figures and stories in it" it is likely that most of the cycle had been completed by that time. The cycle narrates the story of Ursula, taken rather liberally from the *Legenda Aurea*, written by Jacopo da Varagine in 1475. Ursula, the Christian Briton princess, agrees to marry the Prince Hereus of England, provided that he is baptized. Together they go on a pilgrimage to Rome and many young women accompany them. They arrive in Cologne with the Pope himself and are slain by the Huns—an event that had been foretold to Ursula in a dream.

**Room 22** The plan of this small circular room that leads into the Albergo Room was overseen by Francesco Lazzari between 1821 and 1823, who decorated and adorned it with sculptures and bas reliefs by Canova-influenced artists. In this room are shown works by Rinaldo Rinaldi, Antonio Giaccarelli and Jacopo De Martini.

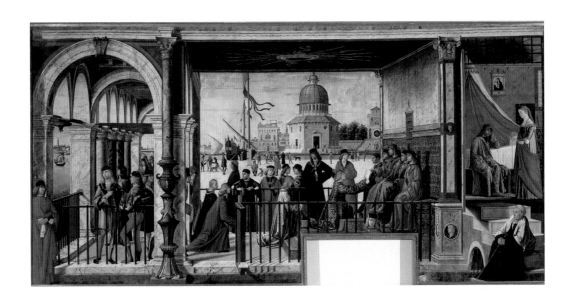

**Vittore Carpaccio**
(Venice ca. 1460–before
June 1526)
*The Arrival of the English
Ambassadors*
Canvas, 278 × 589 cm
(cat. 572)
Acquisition: 1812
Latest restoration: 1983

This canvas incorporates
three separate scenes,
set off by three architectural
elements: the arrival of the
ambassadors at the court
of Britain; the presentation
of Prince Hereus's marriage
proposal; Ursula in her
room relates to her father
the marriage conditions
she requires while the

nurse waits at the foot
of the stairs. The building
in the center is inspired
by the Temple of Jerusalem.
On the right, a clock
similar to that in Piazza
San Marco, inaugurated
on February 1, 1499,
which is the earliest possible
date for the completion
of the painting.

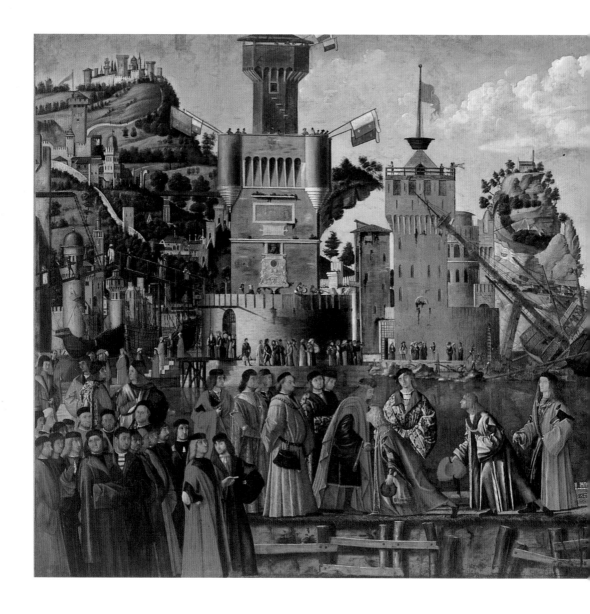

**Vittore Carpaccio**
(Venice ca. 1460–before
June 1526)
*Meeting and Departure
of the Betrothed*
Canvas, 279 × 610 cm
(cat. 575)
Acquisition: 1812
Latest restoration: 1983–84

This canvas is divided into
four episodes: the prince
takes leave of his parents
before departing; the
betrothed meet; the two
betrothed bid farewell to the
king and queen, and lastly
they set sail on the ships
which will bring them
to Rome.

In the background are shown
the locations of the story: on
the left Mediaeval England,
on the right Renaissance
Britain. The work is signed
and dated 1495 at the bottom
in the center.

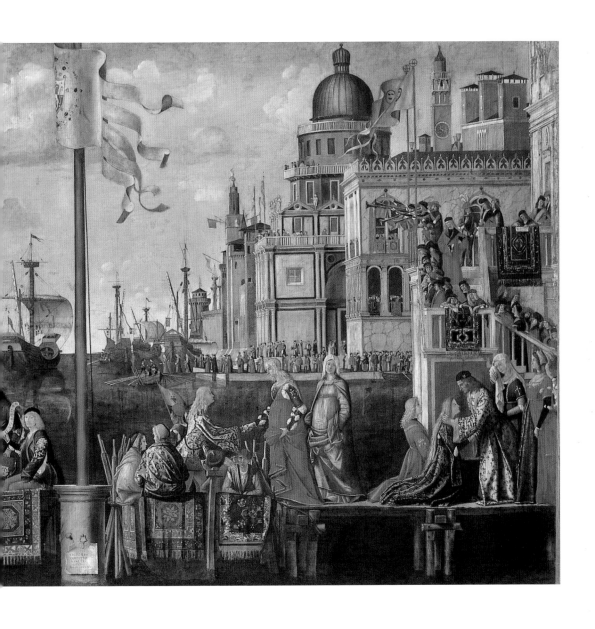

**23** Former Church of Santa Maria della Carità.
Works from the Veneto School
of the Fifteenth Century and Canvases
from the Scuola di San Marco

The founding of the Church of Santa Maria della Carità, which probably occurred at the beginning of the twelfth century, is part history, part myth. According to Sansovino (1581), it was originally a small wooden building "… around a capital of an image of the Virgin, famous for various miracles." Only later was it decided to construct a church in stone on the site. In 1134 some Augustinian monks from Santa Maria in Porto relocated from Ravenna to Venice and built their convent next to the Church of Santa Maria della Carità. According to legend, in 1177 Pope Alexander III—in order to escape from Frederick Barbarossa—hid in the convent for six months and consecrated the church on April 5. From then on, every year on that date the Doge and Venetians of every class—even the inhabitants of the provinces—came to the Church of Santa Maria della Carità to obtain the papal indulgence he had granted for the help received. Crossing the Grand Canal to the church was made easier by the construction of a bridge of boats from Campo San Vidal to Campo della Carità. This custom lasted until the end of the Republic. The old façade of the church can be seen in a painting kept in Room 24, which illustrates the meeting of the doge and the pope. From archival documents we know that at the end of the thirteenth century the

church had an external portico—once very common on Venetian buildings—of which there are now only two examples remaining although modified: one at San Giacomo di Rialto and another at San Nicolò dei Mendicoli. There was also a bell tower for this original structure, which was left intact even during the modifications made in the fifteenth century, until on March 17, 1744, when, due to the erosion at its base, it finally succumbed and toppled into the Grand Canal. There were many illustrious figures buried there as we can deduce from the register published by Tassini in 1876; a part of this register still exists in the Seminary. The ascension of Gabriele Condulmer from the order of the Lateran Canons to the papacy (Eugene IV) in 1431, and his long pontificate, which lasted until 1447, brought new-found glory and power to the monks of La Carità.

In fact, after prolonged negotiations with the members of the Scuola di Santa Maria della Carità, the monks obtained approval to enlarge the church. The new construction began in April of 1441 and was overseen by Bartolomeo Bon. Working with his son, Giovanni, Bon was responsible for all the stone work that carried the new structure: the windows, the door with the lunette above it, the side door, the round eye which was once part of the façade, the

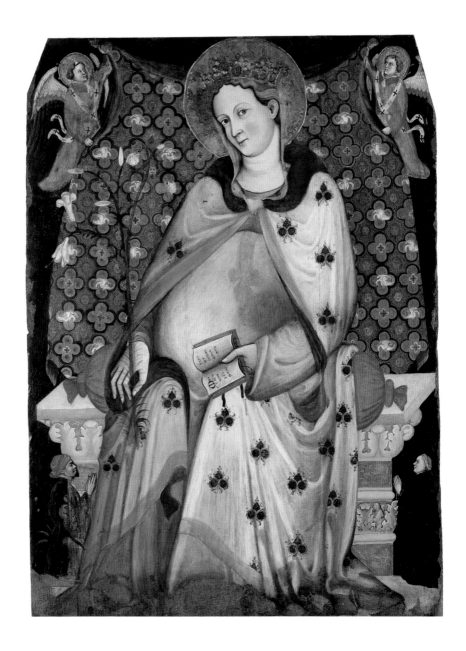

**Maestro della Madonna
del Parto**
*The Madonna del Parto
and Two Devouts*
Panel, 188 × 138 cm
(cat. 1328)
Acquisition: 1916
Latest restoration: 1996

On the open book is an
invocation to the Virgin
Mary, Madonna del Parto.
The work is from the late
fourteenth century and
comes from the church
of Santa Caterina.

statues of Saint Augustine, Saint Jerome and the Holy Father, the small bell towers, the pinnacles, the leaves on the spire of the façade (most of which now lost), the side pillars, the ribs for the archivolts of the chapels, the cantilevers and every other decoration. At the same time, the walls were constructed in brick up to the roof, supported by fifteen beams of enormous dimensions from the region of Cadore, today still resting upon Bon's cantilevers which were completed in May of 1446, with the monogram "Ihesus." In 1450 the apse chapels were built and alongside Bartolomeo Bon we still find "Maestro Pantaleon," who appears to have been associated with Bon in many important workshops in Venice at that time, including the one at Ca' d'Oro. The decoration painted with large leaves which runs under the scarp wall of the roof and surrounds the eye on all the windows was the work of Ercole, the son of Jacobello del Fiore, who, in 1449, received 50 ducats for all work "carried out in the Carita" and another 12 on December 1, 1453 for the decoration of the chapel. Once the construction was completed, the friars decorated it with precious works of art. In 1453 a Madonna was bought from Donatello, who was sojourning in Padua at the time; the painting was placed over the door of the sacristy. Other works were commissioned from Jacopo, Gentile and Giovanni Bellini and their studio and from Cima da Conegliano. Many important funereal monuments were also erected, such as the one for the doges Marco and Agostino Barbarigo. Parts of these statues remain today and are preserved in the Franchetti Gallery at Ca' d'Oro and in the Seminary. In 1807, the whole complex of the Carità—comprising the convent, church and school—was chosen to be the site of an Academy of Fine Arts and an accompanying gallery. Begun in 1811, the modifications were headed by the architect Giannantonio Selva. The church was completely overhauled: every decoration was removed, the "barco" (low porticoed wing) and the chapels were destroyed, the Gothic windows were walled over and the entire space was divided horizontally to create five large rooms on the upper floor, lighted by skylights for exhibiting. The bas relief work by Bartolomeo Bon on the façade showing the *Coronation of the Virgin* was removed, and is now preserved in the old sacristy of the Church of the Salute. From 1921 to 1923, under the direction of Gino Fogolari and with the architect Aldo Scolari, the whole space with the apses was restored including the truss ceiling and the Gothic windows on the side walls. In 1948 the room was remodeled by Carlo Scarpa. Out of respect to the few original architectural features remaining, the arrangement took on the appearance of a provisional exhibition space. Today the room is largely kept free to provide space for temporary shows, although some important works are on permanent display along the walls. At the end of the nineteenth century the remains of glass frames from the second half of the fourteenth century were placed on the windows of the central chapel; these frames once decorated the minor apses of the Church of Santi Giovanni e Paolo. In this room are shown works by Jacopo Bellini, Gentile Bellini, Giovanni Bellini, Alvise Vivarini, Nicolò di Pietro, Bartolomeo Giolfino, Maestro della Madonna del Parto, Bartolomeo Vivarini, Carlo Crivelli, Vittore Belliniano, Giovanni Mansueti, Jacopo Palma il Vecchio and Paris Bordon.

---

**Bartolomeo Vivarini**
(Venice ca. 1430–records up until 1491)
*Madonna and Sleeping Child Enthroned with Saints Andrew, John the Baptist, Dominic and Peter*
Panels, gold ground,
131 × 49 cm (central),
107 × 33 (sides)
(cat. 615)
Acquisition: 1812

Latest restoration: 1994
In the center compartment toward the bottom is the signature and date of 1464. The polyptych comes from the Church of Sant'Andrea on the island of Certosa, where it was placed at the altar of the Ca' Morosini chapel.

**Alvise Vivarini** (Murano 1442/43–died between 1504 and November of 1505)
*Madonna Enthroned with Saints Louis of Toulouse, Anthony of Padua, Anne, Joachim, Francis and Bernard of Siena*
Panel, 175 × 196 cm
(cat. 607)
Acquisition: 1812
Latest restoration: 1993

On the base of the throne are the date 1480 and the signature. The work was originally on the altar of Santa Maria della Prà and then on the altar of San Bernardino in the church of San Francesco in Treviso.

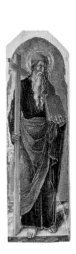
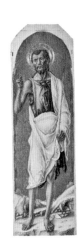
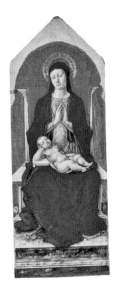
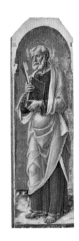
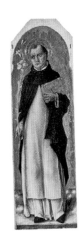
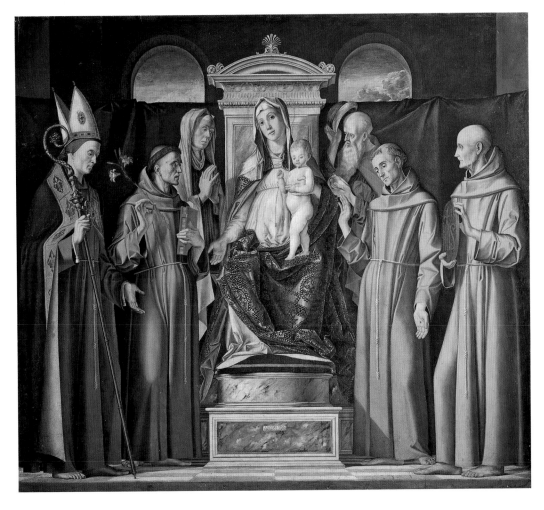

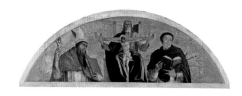

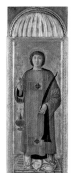
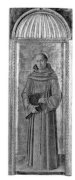
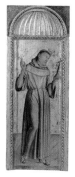
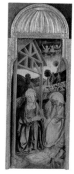
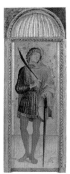

## The Apse Triptychs

On the side walls of the apse are four triptychs that were originally in the Chiesa della Carità, on the altars of the noble chapels up against the "barco" (a structure similar to a chancel) erected between 1460 and 1464, while in 1471 all the altars were consecrated. Traditionally attributed to Vivarini, these triptychs were later brought back to Bellini, at Jacopo's studio, whose drawings are recorded with his first collaboration with Giovanni and Gentile, connecting them to the end of the seventh decade. The archaic use of a gold ground could be attributed to the use of assistants from Murano or to the wishes of the commissioners of the work. Nevertheless, the overall form of the works, with the lunettes above, borrowed from Mantegna's altarpiece for San Zeno in Verona, must have had a great impact on Venetian artistic culture.

Jacopo Bellini, Gentile Bellini, Giovanni Bellini and collaborators
*Saint Lawrence and the Madonna Polyptych,*
in the lunette
*Madonna and Child with Angels*
Panels, gold ground,
103 × 45 cm (Saints Lawrence and John the Baptist),

127 × 48 (Saint Anthony),
57 × 188 (the lunette, divided at the back into three parts)
(cat. 621/B)
Acquisition: 1812
(Saints Lawrence and John the Baptist),
1834 (Saint Anthony),
1923 (the Madonna),
1954 (the two angels)
Latest restoration: 2000

Jacopo Bellini, Gentile Bellini, Giovanni Bellini and collaborators
*Nativity and Saints Francis and Victor Triptych*
in the lunette
*Trinity between Saints Dominic and Ubaldo* (?)
Panels, gold ground,
103 × 45 cm (Nativity),
127 × 48 (Saints Francis and Victor),

60 × 166 (lunette)
(cat. 621)
Acquisition: 1834 (the saints), 1891 (Nativity), 1923 (the lunette)
Latest restoration: 2000

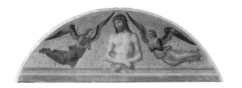

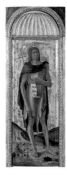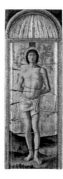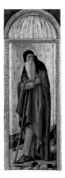

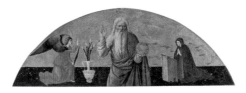

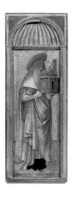

**Jacopo Bellini, Gentile
Bellini, Giovanni Bellini
and Collaborators**
*Saint Sebastian with
Saints John the Baptist
and Anthony Triptych*
in the lunette
*Christ in Pietà
with Two Angels*
Panels, gold ground,
103 × 45 cm

(Saint Sebastian and
Saint Anthony Abbot),
127 × 48 (John
the Baptist),
60 × 166 (lunette)
(cat. 621/A)
Acquisition: 1821 (Saint
Sebastian and Saint
Anthony), 1834 (John the
Baptist), 1927 (lunette)
Latest restoration: 2000

**Jacopo Bellini, Gentile
Bellini, Giovanni Bellini
and Collaborators**
*Madonna with Child
and Saints Jerome
and Ubaldo Triptych*
in the lunette
*Eternal Father
and the Annunciation*
Panels, with gold ground,
127 × 48 cm (each),

59 × 170 (lunette)
(cat. 621/C)
Acquisition: 1834
(Madonna and Saints),
1919 (lunette)
Latest restoration: 2000

## Canvases from the Albergo Room of the Scuola Grande di San Marco

The five canvases located at the back of the church, together with the *Sermon of Saint Mark at Alexandria* by Gentile Bellini and the *Baptism of Saint Mark* by Giovanni Mansueti—today in the Brera Museum—were part of the original decoration of the Albergo Room of the Scuola di San Marco. In 1492 Gentile and Giovanni Bellini offered to paint the room, and came to an agreement with the Scuola. However, Gentile died in 1507 without finishing the *Sermon*, which was completed by Giovanni. In 1515 the Scuola hired Giovanni to paint the *Martyrdom of Saint Mark*, but unfortunately on November 29, 1516, the artist died and the work was left unfinished until Vittore Belliniano completed it in 1526. Later works were commissioned from Giovanni Mansueti, collaborator and disciple of Gentile Bellini, thus guaranteeing the stylistic continuity of the cycle. Mansueti died in 1526 or 1527, and the last two paintings, the *Presentation of Saint Mark's Ring* by Paris Bordon, and the *Sea Storm* by Palma il Vecchio, reveal a radical change in the taste of the commissioners. When the Scuola was suppressed by Napoleonic decree in 1806, the cycle was dispersed, with pieces in Milan, Venice and Vienna. The works in Vienna were returned in 1919 and the cycle was re-assembled and placed on display in the Galleries, but without the paintings in the Brera Museum, in 1994.

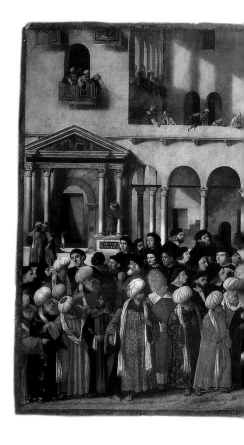

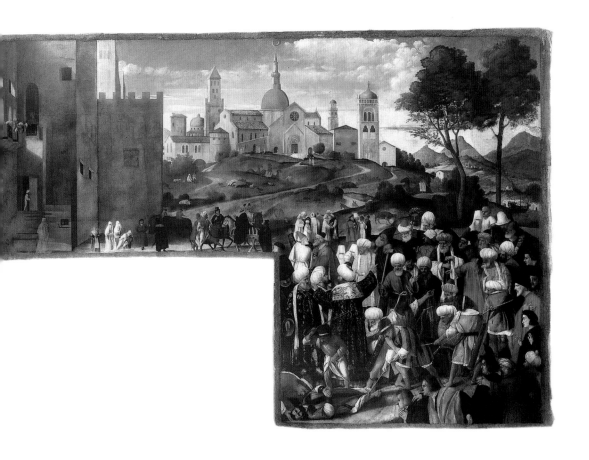

**Giovanni Bellini**
(Venice 1434/39–1516) and
**Vittore Belliniano**
records from 1507 to 1529
*Martyrdom of Saint Mark*
Canvas, 362 × 771 cm
(cat. 1002)
Acquisition: 1919
Latest restoration: 1987–94

On July 4, 1515, the Scuola commissioned Giovanni Bellini to paint a canvas with the story of Saint Mark, who "... in Alexandria was dragged along the ground by those infidel Moors." When Giovanni died in 1516, the work was completed by Vittore Belliniano who placed his signature on it

and the date of 1526—ten years later. The drawing and layout of the great canvas are doubtless the work of Giovanni, but the actual painting of the canvas was by Vittore with perhaps some suggestions from Lorenzo Lotto.

**Room 23**

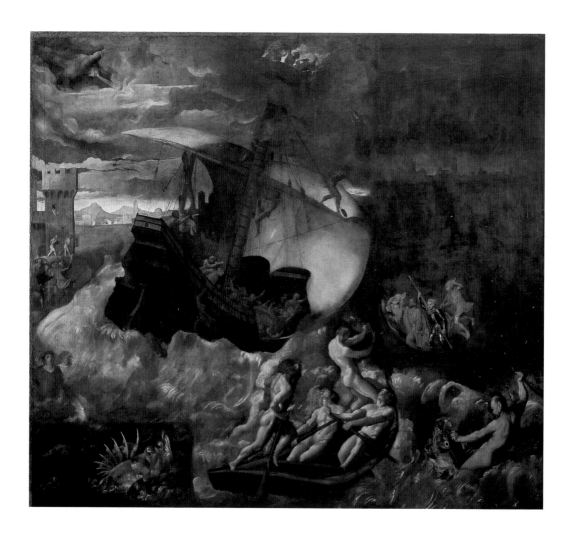

**Jacopo Palma il Vecchio**
(Serina, Bergamo,
ca. 1480–Venice 1528) and
**Paris Bordon**
(Treviso 1500–Venice 1571)
*Sea Storm*
Canvas, 362 × 408 cm
(cat. 516)
Acquisition: 1829
Latest restoration: 1993–94

This work depicts the
legend of Venice saved
from destruction by devils
through the intercession
of Saints Mark, George
and Nicholas, who appeared
to a fisherman in his boat
during a storm. The painting
was probably commissioned
immediately prior to the
death of Palma in 1528,
and so he may not have
had the time to finish
the canvas, which was
completed or repaired
by Paris Bordon in 1534.

**Paris Bordon**
(Treviso 1500–Venice 1571)
*Presentation of Saint Mark's
Ring*
Canvas, 370 × 300 cm
(cat. 320)
Acquisition: 1815
Latest restoration: 1988

On the base of the pillar
at right is the signature.
The work shows the
fisherman who offers the ring
of Saint Mark to the doge
as proof of the miraculous
events of the night before.
Surrounding doge
Andrea Gritti (1522–1538)
are the senators, while on
the left is the great guardian
and a group of members
of the confraternity.
The execution of the canvas
was decided in 1534, but it
was probably painted around
the first half of the 1550s.

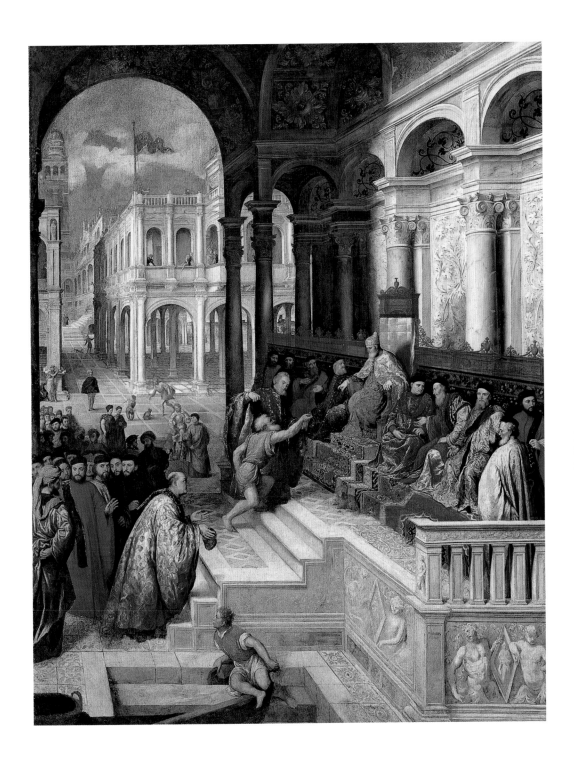

# 24  Former Albergo Room of the Scuola di Santa Maria della Carità. Antonio Vivarini and Giovanni d'Alemagna, Titian

This was the Albergo Room of the Scuola di Santa Maria della Carità, where the most highly ranked members met, and where the registers, charters (called the "mariegola"), and the relics were all kept. The ceiling, gilt and multicolored, with the four *Evangelists*, dates from the end of the fifteenth century. The *Holy Father* at the center was probably taken from a previous ceiling in the Assembly Hall which may have been destroyed by fire. In 1811 Selva opened the short stairway; for this occasion the wooden altar was disassembled and the triptych by Antonio Vivarini and Giovanni d'Alemagna was moved to the right wall. In this room are shown works by Antonio Vivarini and Giovanni d'Alemagna, Titian, the Veneto-Byzantine school of the fourteenth and fifteenth centuries, an anonymous artist of the sixteenth century and the Venetian school of the sixteenth century.

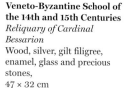

**Veneto-Byzantine School of the 14th and 15th Centuries**
*Reliquary of Cardinal Bessarion*
Wood, silver, gilt filigree, enamel, glass and precious stones,
47 × 32 cm
(cat. S19)
Acquisition: 1919

Donated to the Scuola della Carità in 1463 by Cardinal Bessarion, with the suppression of the Scuola it passed into the collection of Luigi Savorgnan, then to Abbot Luigi Celotti, who sold it to the Emperor Francis I in 1821. It was assigned to the galleries as one

of the works restored by the Austrians after World War I. The precious piece is formed of a cross with Christ encased on an enameled tablet which includes four rock crystal cases containing the "Holy Wood" and "Holy Shroud" relics, two plates with the archangels Gabriel and Michael,

Constantine and Saint Helen painted on glass, a cover composed of a fixed part framing the reliquary on three sides with seven small scenes from the Passion and a moveable shutter cover on which the Crucifixion is depicted.

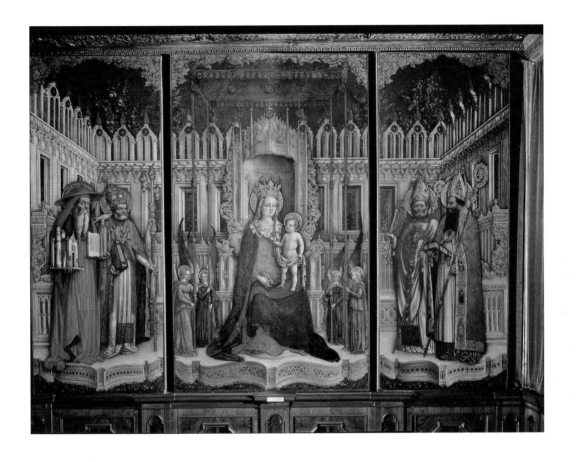

**Antonio Vivarini**
(ca. 1418/20–1476/84) and
**Giovanni d'Alemagna**
records from 1441 to 1450
*Madonna Enthroned
with Saints Jerome, Gregory,
Ambrose and Augustine*
Canvases, 344 × 203 cm
(central), 344 × 137 (sides)
(cat. 625)

Acquisition: 1807
Latest restoration: 1999

On the step of the throne
is written the date 1446
and the signature.
One of the oldest Venetian
paintings on canvas, it is
certainly the most unified
work the two artists

produced in their problematic
collaboration. The Virgin
and angels are clearly
attributable to Vivarini.
The new understanding
of perspective emerges clearly,
despite the overabundance
of the decorations.

**Room 24**

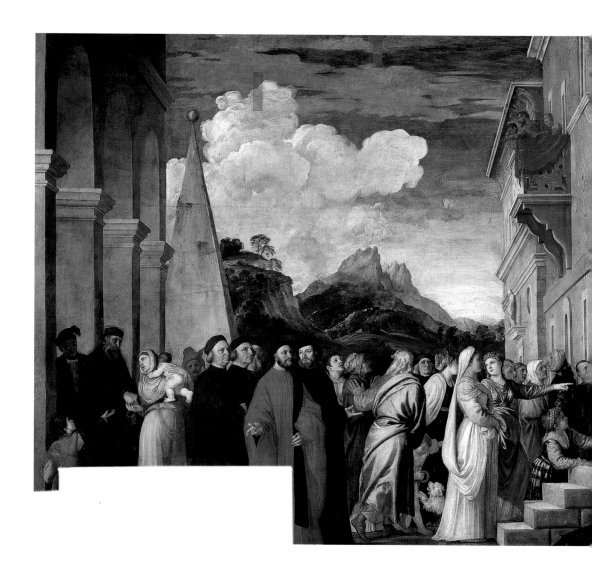

**Titian**
(Pieve di Cadore ca. 1488/90
–Venice 1576)
*Presentation of the Virgin*
Canvas, 335 × 775 cm
(cat. 626)
Acquisition: 1807
Latest restoration: 1981

This large canvas was
painted for the Albergo
Room of the Scuola della
Carità between August 21,
1534 and March 6, 1539.
It appears to have been
cut below to accommodate
a door. If the horizontal
path of the wall has imposed

a certain design taken
from the Venetian narrative
tradition—and mostly
from Carpaccio—it does
so with an extraordinarily
"modern" spirit and
a deep awareness
of the contemporary
architectural notions

proposed by Sansovino
and Serlio. The perfect
balance between architecture
and landscape, and of both
with the open procession
of the members of the
confraternity, firmly
establishes the unity
of the work.

*Photograph Credits*
Archivio della Soprintendenza speciale
per il patrimonio storico, artistico
ed etnoantropologico per il Polo museale
della città di Venezia e dei comuni
della Gronda lagunare
Mondadori Electa Archive, Milan,
courtesy Ministero per i Beni
e le Attività Culturali

Thanks go to the Photographic Archive
of the Soprintendenza, and especially
Diana Ziliotto